THE
Archive Photographs
SERIES

BARKING
AND
DAGENHAM

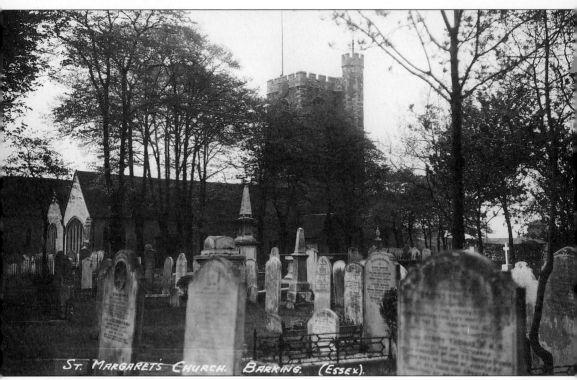

St Margaret's church from the graveyard, 1920s. Believed to have been built around the thirteenth century as a chapel, it stood within the precincts of the Abbey where its vicars and worshipppers attended on the dedication day (13 July) every year. Abbess Anne de Vere is said to have made it a parish church, *c.* 1300.

THE
Archive Photographs
SERIES

BARKING

AND

DAGENHAM

Compiled by
Gavin Smith

CHALFORD

The Chalford Publishing Company
St Mary's Mill, Chalford,
Stroud, Gloucestershire, GL6 8NX

ISBN 0 7524 0739 2

Typesetting and origination by
The Chalford Publishing Company
Printed in Great Britain by
Redwood Books, Trowbridge

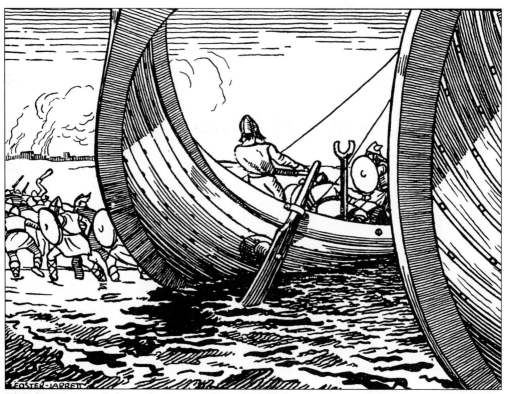

The destruction of the early Saxon Abbey in 870 by the Danes, from a reconstruction by Foster Jarrett.

Contents

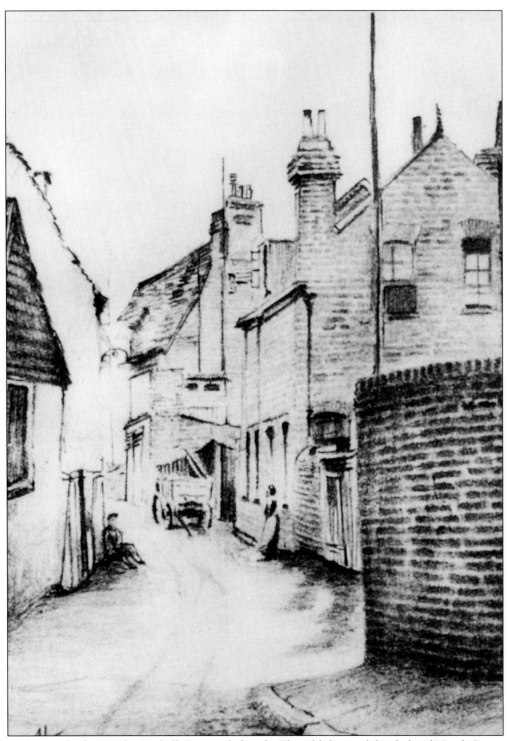

Back Lane leading to the Firebell Gate and church. This old thoroughfare behind North Street and the Broadway was swept away in the name of progress. It gave the old town part of its venerable atmosphere.

Introduction

Barking and Dagenham have been sister communities along the Thames shore from Saxon times. Their first links with the rest of the region were by water. The land in the area was a wilderness of marsh which was difficult to cross though some brushwood trackways were laid down in imitation of those constructed by the earliest inhabitants of these wastes. Much of this siting was, of course, for defensive purposes. It is now believed that these Saxon constructions assisted the later Romano Britons to defend the area from further incursions by the Norsemen from across the sea.

The region then became the site for an Abbey, a very early charter records the granting of land and privileges to this religious house. An eighth-century copy of 'Hodildred's Charter' mentions a grant of lands by him to add to those already given by King Sebbi of the East Saxons. The Danes came and laid waste to the Abbey, but it was rebuilt and finally became one of the most important centres of religion and learning in Christendom. Kings and Queens of the Middle Ages were often involved with its welfare and progress. The main Abbey building was in the shape of a cross, 330 feet long and the whole site covered 11 acres. In later years Barking had connections with the City of London – eight Lord Mayors were drawn from among the local merchants and gentry. A fishing industry of increasing scale flourished from mediaeval times to the nineteenth century, when Hewetts, the local fishing magnates, moved their operations to the East Coast.

Dagenham also had a local gentry from the Middle Ages and their seats studded the country fields and hills. One such family was the Fanshawes. Though much of Dagenham came under the rule of Barking Abbey in earlier times, the area became part of the Romford Rural District and had to wait till 1926 to gain its independence. Its wealth of hidden history was collected and recorded from national and county archives and the first librarian of Dagenham Urban District ensured that it was made available to the public through the Valence Museum and local history library. Through these records we learn of valiant attempts through the centuries to stem the inroads of the Thames on the low lying river marshes. These marshes were mostly only available in the summer months for light farming activities such as the grazing of sheep. A huge inundation at the beginning of the nineteenth century led to the creation of a lake-like arm of the Thames covering a large area of Thameside Dagenham known as Dagenham Gulf (Gulph). Various attempts to drain this and reduce the area it covered were only partially successful. The twentieth-century development of these marshes and the creation of dock facilities, railway networks and sites for factories owes much to the family and firm of Samuel

Williams who gradually created a new environment for industry along the Thames bank here, starting with the purchase, in 1887, of certain riverside lands in Dagenham Marsh. Thus the days of the country fishermen who visited the Gulf to catch the teeming fish it contained and of lonely water meadows, were numbered.

As we know, after a giant feat of construction, the Ford Company came to the levelled site created out of marsh and opened their works built on a raft of piles. The factory grew and a new community came to the inland wastes from London, swamping the original inhabitants of Dagenham village as the huge Becontree Estate took shape from the mid 1920s to stand alongside the car factory and also provide part of the workforce. Modern Dagenham was born.

Firebell Gate and Curfew Tower, two of the names of this old entrance to the grounds of Barking Abbey and the churchyard. This late nineteenth-century view was mostly unchanged well into the twentieth century. Now only the tower remains in splendid isolation.

One
Old Barking Town

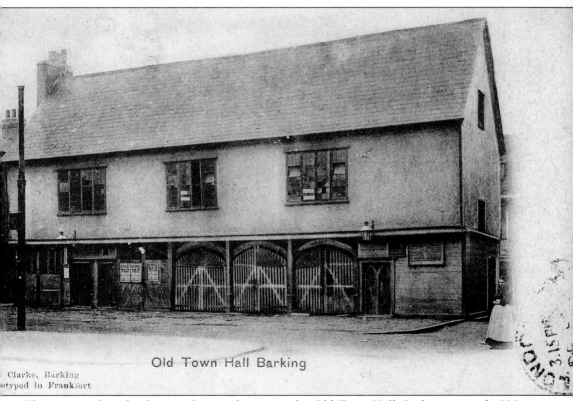

Old Town Hall Barking

Clarke, Barking
otyped in Frankfort

The court and market house otherwise known as the Old Town Hall, Barking, around 1903. From Elizabethan times it had been one of the town's most prominent structures. Queen Elizabeth is supposed to have contributed towards it and a Royal Coat of Arms in plaster in the building bore the date 1588.

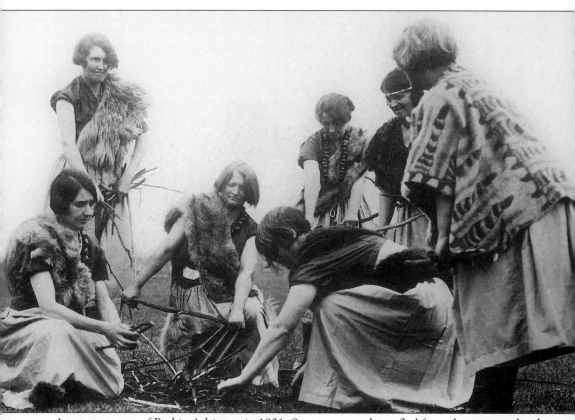

A re-enactment of Barking's history in 1931. Saxon women have fled from the town under the onslaught of the Danes who have set fire to the Abbey and destroyed the settlement in 870.

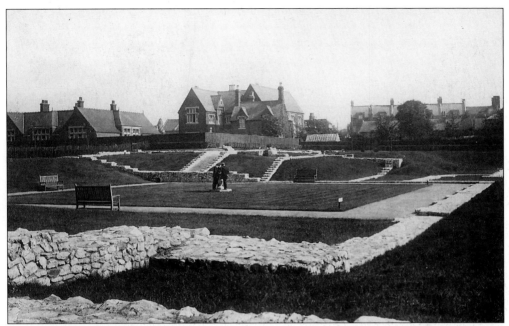

Barking Abbey ruins. The walls were excavated and laid out as a historical landmark. This is a view of the Cloisters in 1920. The Abbey covered eleven acres and at its height was a truly magnificent group of buildings, with one gate leading straight on to the river. At the back of this view can be seen the Church of England National School of 1872.

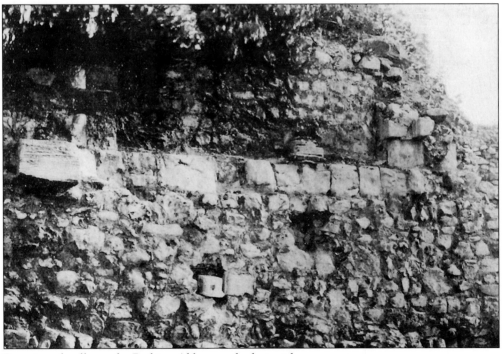

Remains of wall-arcade, Barking Abbey south choir aisle.

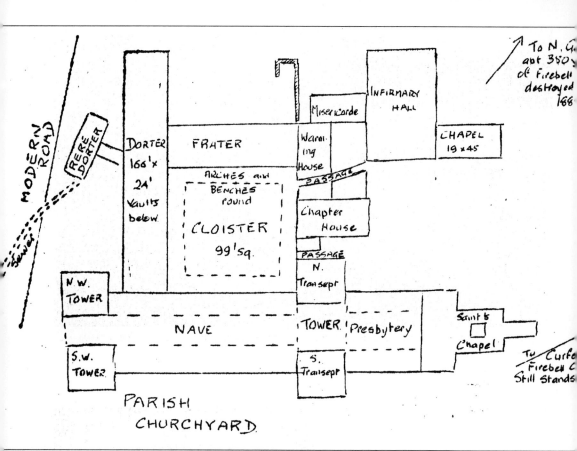

Plan of the Abbey layout attached to a twentieth-century transcription of the accounts of James Needham, Surveyor-General to Henry VIII. This contains a wonderful description of how the Abbey fabric was taken apart at the Dissolution. Among other items, it mentions the building materials – from the early Caen Stone, Barnack Stone and Binstead Stone to the later Reigate Stone until in its final days some brick was being used.

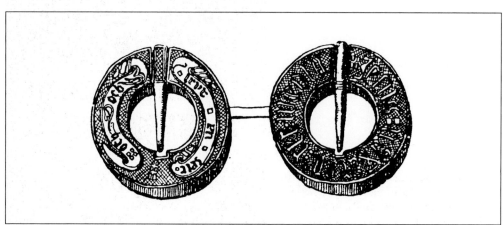

Ancient Fibula, found in the ruins of Barking Abbey.

William the Conqueror, in his military costume, receives Saxon fealty – a scene from the Charter pageant, 1931.

William I at Barking Abbey, after his coronation on Christmas Day, 1066. He moved his headquarters to the town while the Tower of London was being constructed.

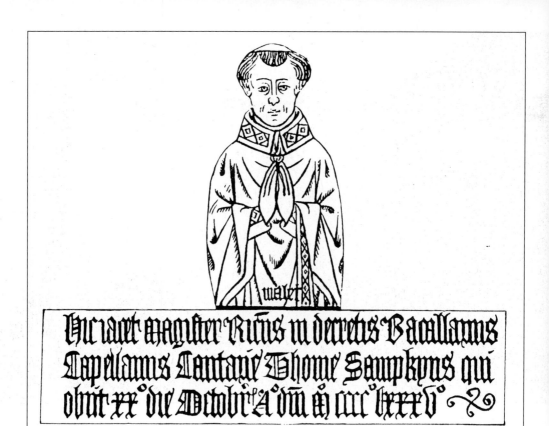

A priest of Barking, 1485.

Outside the walls. The original Abbey had both priests and nuns. Later it needed administrators, such as the Cellaress, whose records have survived, to control the activities of what was a large and complicated community like a small town.

14

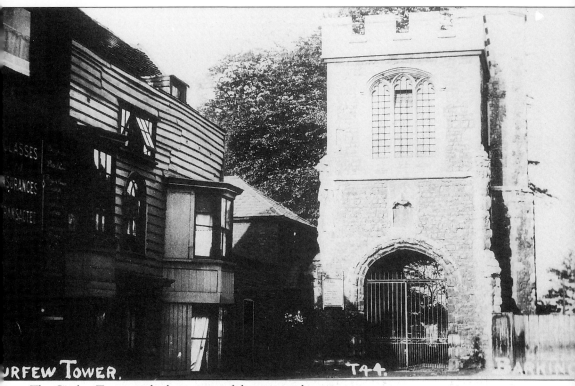

The Curfew Tower at the beginning of the twentieth century.

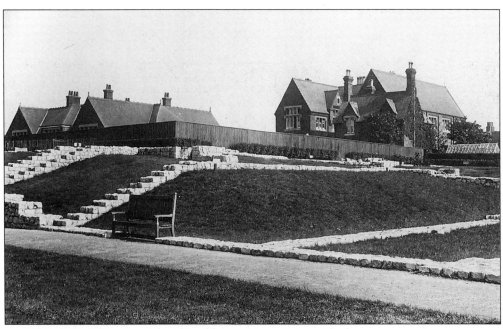

Another view of the ruins – the chapel house remains are marked out in stone.

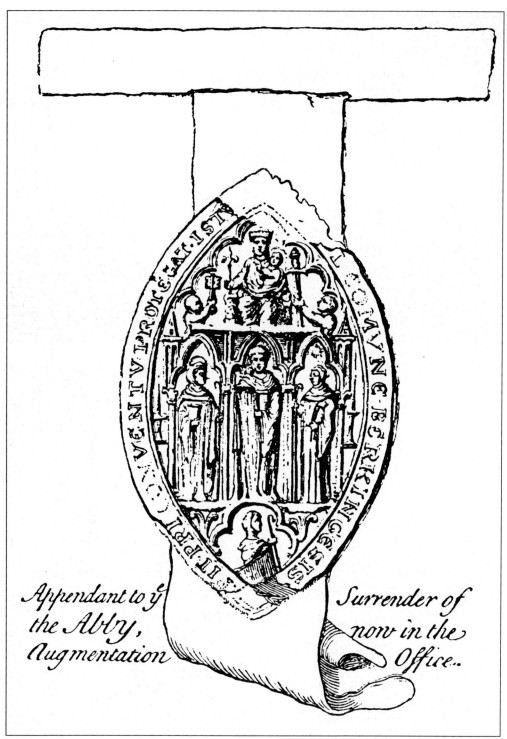

Appendant to ỹ
the Abby,
Augmentation

Surrender of
now in the
Office...

Ecclesiastical figures decorate this seal attached to the Abbey surrender document at the Dissolution. The nuns were given some consideration as the Abbess was related to the official who carried out Henry VIII's orders.

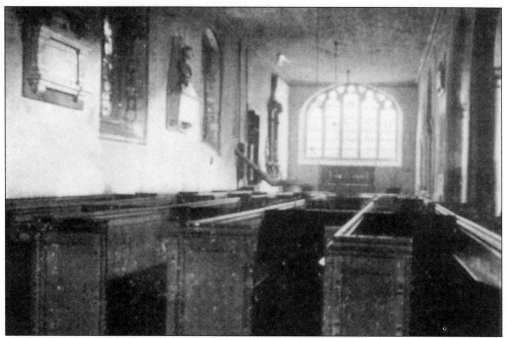

The north aisle and lady chapel of Barking church in 1928, before repairs were carried out.

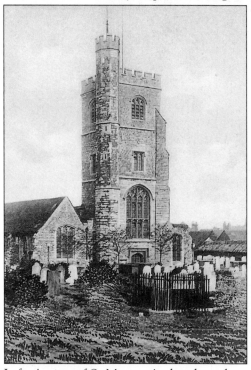

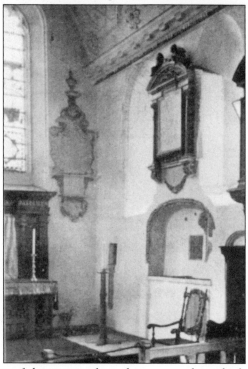

Left: A view of St Margaret's church at the turn of the century from the graveyard in which there are many interesting memorials of important people formerly connected with the town. Right: A corner of the sanctuary, Barking church in the 1930s. The memorial to Sir Charles Montague is on the right.

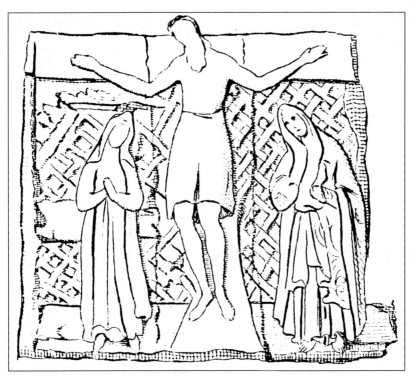

A drawing of the Holy Rood, much defaced from the small chapel above the Firebell Gate, sketched around 1813.

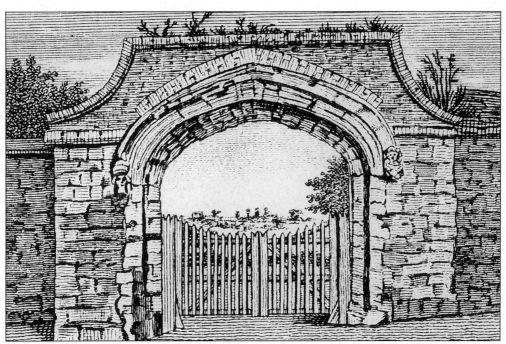

The north gate of Barking Abbey, c. 1800. The tower having long since gone, it was at this time only an archway and these remains were demolished in 1881.

Two
Pride of Barking

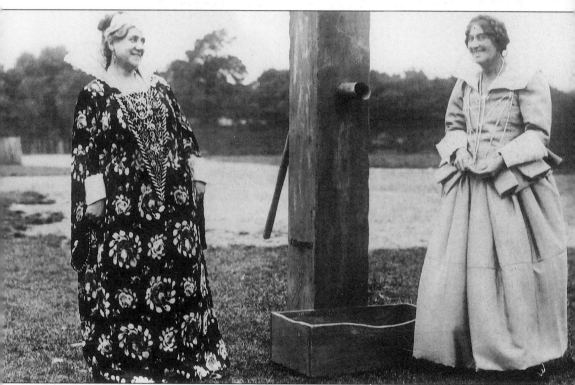

Eighteenth-century Barking ladies by the village pump at the Great Barking Fair, 1746, recreated at the 1931 pageant. Barking people were very proud of their right to hold markets and an annual fair.

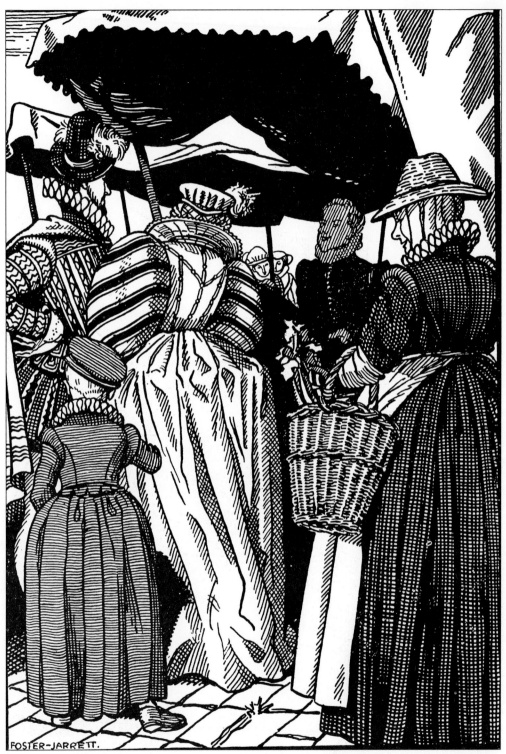

A scene at an Elizabeth market after the granting of the Charter gave market rights to the town – recreated by Foster Jarrett.

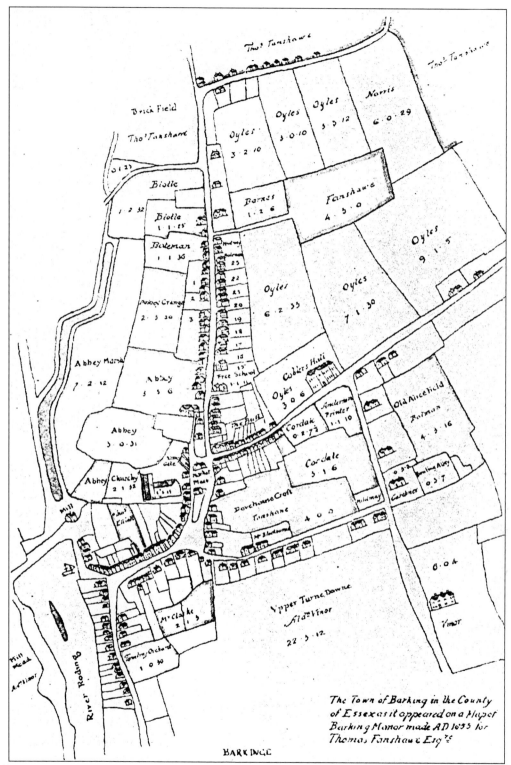

A 1650s map of Barking Town drawn up for the Lord of the Manor, Thomas Fanshawe.

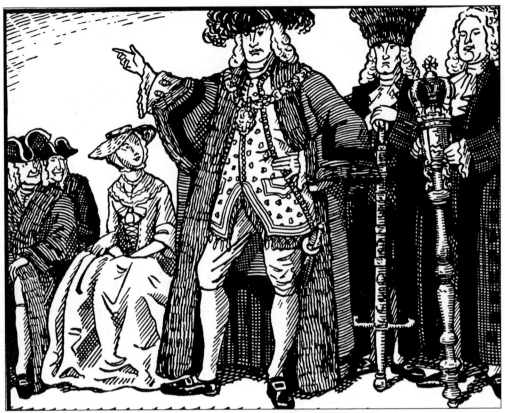

Sir Crisp Gascoyne, Lord Manor of London and a Barking man, visits the Great Barking Fair of 1746 – as seen by Foster Jarrett.

Not the Barking Fair, which was suppressed in 1875, but a funfair before the First World War.

Trotting at Parsloes Park became a firm favourite as an entertainment as seen in this programme for 21 July 1902.

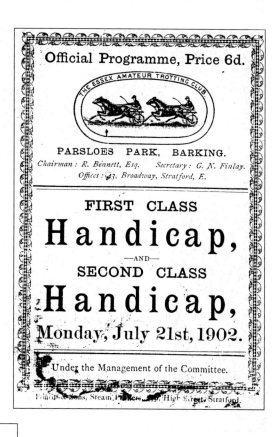

Official Programme, Price 6d.

THE ESSEX AMATEUR TROTTING CLUB

PARSLOES PARK, BARKING.

Chairman : R. Bennett, Esq. Secretary : G. N. Finlay.
Offices : 43, Broadway, Stratford, E.

FIRST CLASS

Handicap,

—AND—

SECOND CLASS

Handicap,

Monday, July 21st, 1902.

Under the Management of the Committee.

Philip & Sons, Steam Printers, 119, High Street, Stratford.

The Next Meeting
WILL BE HELD
Monday, August 11th, 1902.

First Class Handicap
For Members only. Distance 1 Mile & Half. Entrance Fee £1 1 0

1st Prize Value £40. 2nd £15.
3rd £10.
Winners of Heats not gaining a Prize to receive £5.

ALSO

A Class Handicap
For Members' Horses that have never beaten 2-30.
Winner to Win Twice. All Horses to go in Harness.
Distance 1 Mile and a Half. Entrance Fee £2 2 0.

PRIZES.—Entrance Fees with £20 Added.
Entries for these Handicaps will close by the first post Thursday. August 7th, 1902.

Racing commences at 2 o'clock.

ADMISSION TO THE PARK 5/-
Tickets can be obtained of G. N. Finlay, 43, Broadway, Stratford, E.

Details of the next meeting from the programme of 11 August 1902.

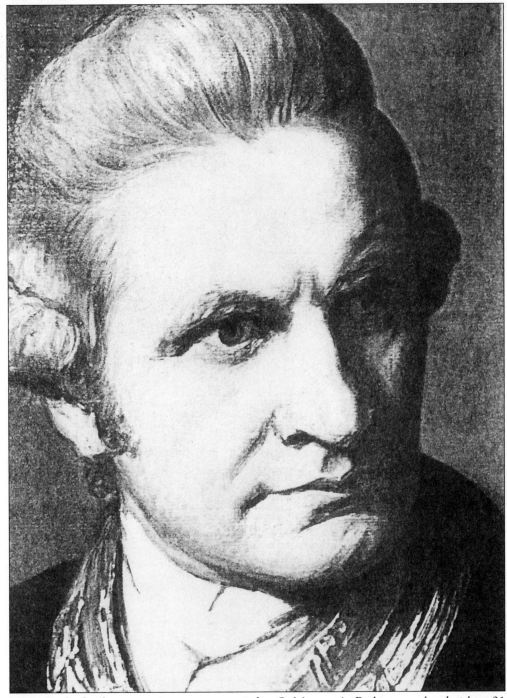

James Cook, the famous navigator, was married at St Margaret's, Barking to a local girl on 21 December 1762.

The Register Book containing the entry of the
marriage.

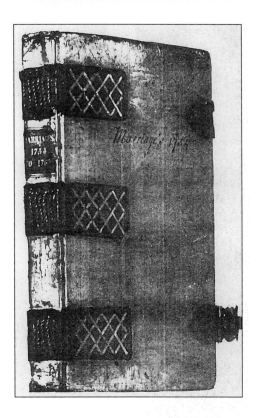

The entry in the Marriage Register.

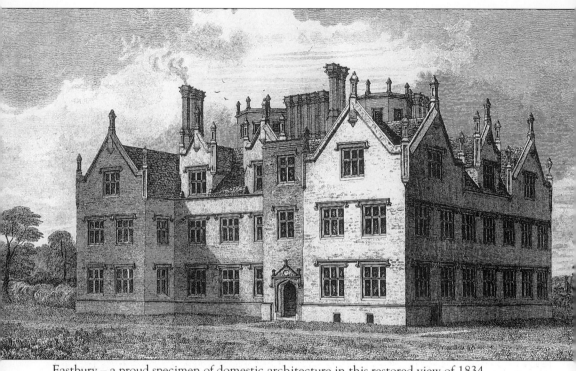

Eastbury – a proud specimen of domestic architecture in this restored view of 1834.

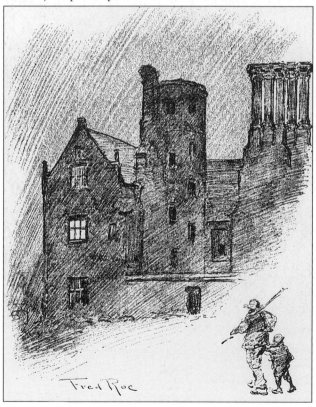

Fred Roe

An imaginative reconstruction of part of Eastbury House by Fred Roe. The house has survived but is only a part of what once stood on the site, some sections having been demolished by successive owners, particularly in the nineteenth century.

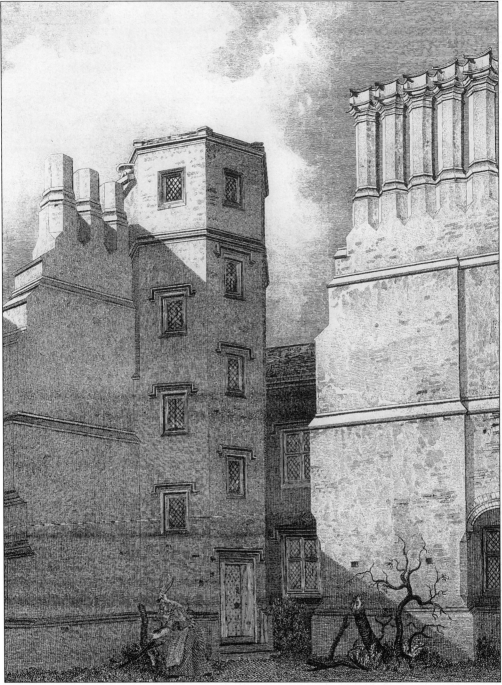

The Inner Court, 1834, showing a corner tower and chimneys. The house was originally built by Clement Sysley, a rich merchant, in the late 1550s.

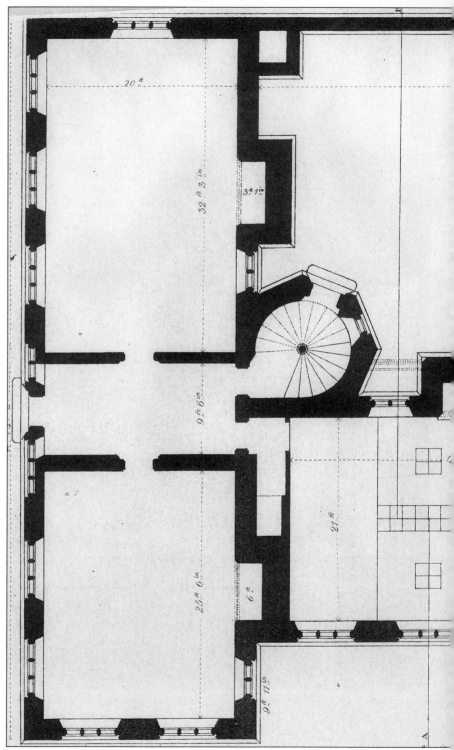

A plan of Eastbury House, 1834, showing some of the servant's arrangements.

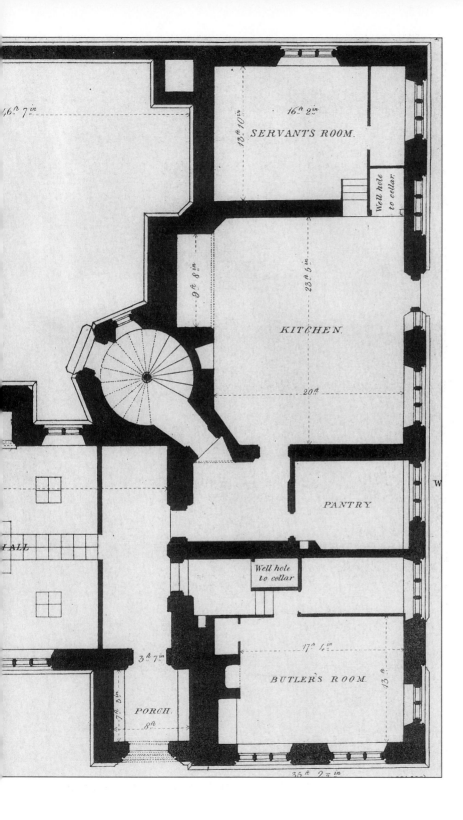

46.ᶠᵗ 7.ⁱⁿ

16.ᶠᵗ 2.ⁱⁿ

15.ᶠᵗ 10.ⁱⁿ

SERVANTS ROOM.

Well hole
to cellar

9.ᶠᵗ 8.ⁱⁿ

23.ᶠᵗ 5.ⁱⁿ

KITCHEN.

20.ᶠᵗ

HALL

W.

PANTRY

Well hole
to cellar

17.ᶠᵗ 4.ⁱⁿ

3.ᶠᵗ 7.ⁱⁿ

13.ᶠᵗ

BUTLER'S ROOM.

7.ᶠᵗ 3.ⁱⁿ

PORCH.

8.ᶠᵗ

36.ᶠᵗ 7.ⁱⁿ

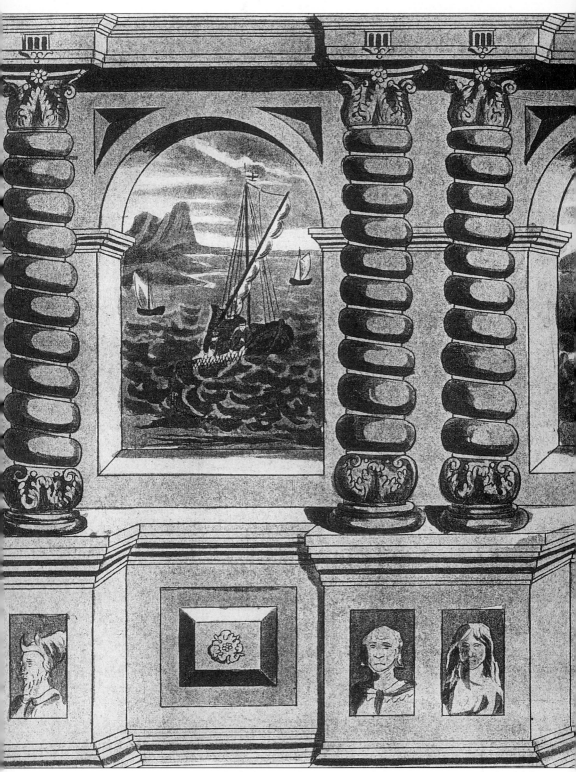

The west side of the room over the hall at Eastbury contained these interesting murals of fishing

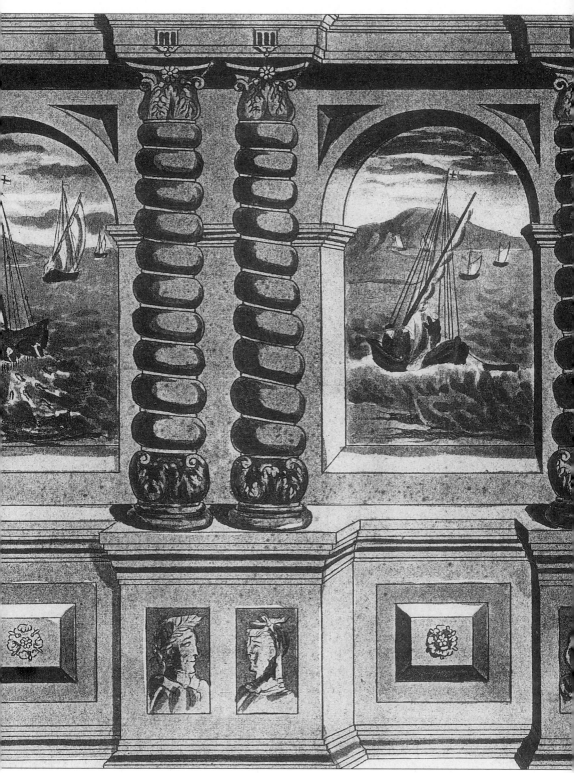

scenes, reminding us of the long history of Barking's fishing industry.

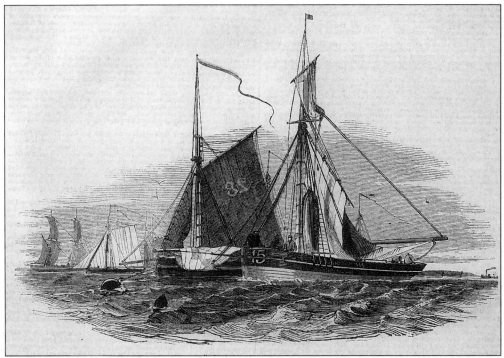

Barking fishing boats at work, 1844. The local industry flourished from the fourteenth century until the mid-nineteenth century. Hewett's 'Short Blue' fleet and 'Home' fleet dominated until the easy access the railways provided to the East Coast began to cause the Barking ports' decline.

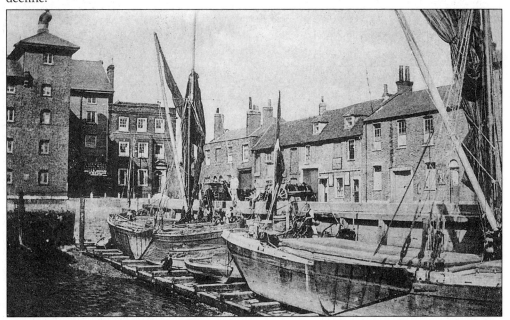

The Town Quay around 1890. After the fishing fleet had gone to the East Coast this area fortunately gained many other manufacturers such as jute spinning from 1866 to 1891 in Fisher Street, which is now Abbey Road, and various chemical works on Barking Creek.

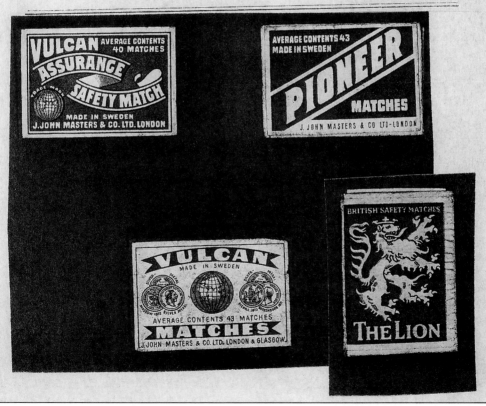

SUPPORT LOCAL INDUSTRY

BY BUYING

"Britain's Hope"

Non - Poisonous Matches

MANUFACTURED BY

The Premier Match Co., Ltd.,

ABBEY ROAD. BARKING.

BEST QUALITY ONLY.

J. John Masters ran a match factory close to the Town Quay and produced and sold many brands – the earlier ones gave their addresses as Barking and London.

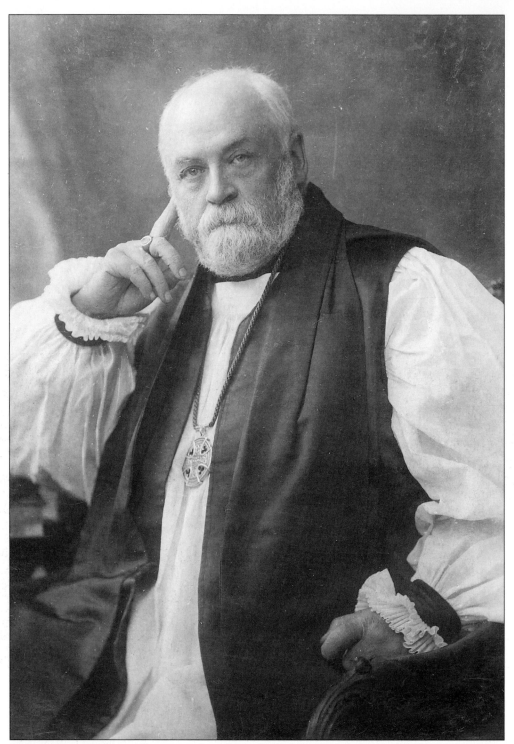

There was excitement in the town when Edward VII appointed the venerable Thomas Stevens to the newly created Bishopric of Barking. He was consecrated on 17 February 1901 and the appointment recognised the importance of the fast growing town and its region.

Three
Moving Forward: Barking's Progress

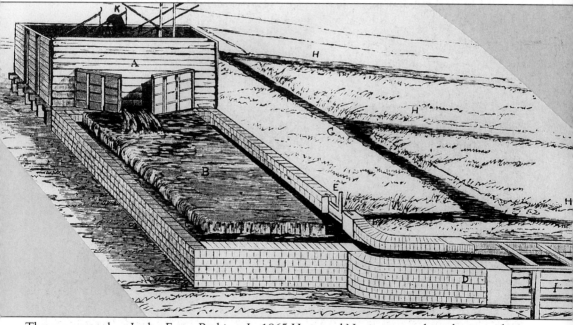

The sewage tank at Lodge Farm, Barking. In 1865 Hope and Napier set up this scheme to draw off sewage from the North London outfall in order to irrigate the farmlands of Essex and grow better crops. Some of it was even to be transported to Maplin Sands to aid in their agricultural reclamation. Essex sea-sand was brought to Barking by barge to simulate the Maplin conditions. The scheme at Lodge Farm continued until 1868. It was halted by opposition from other scientists and the failure to raise sufficient capital for the whole project. Following the closure of this venture, Hope set up a model sewage farm at Bretons, South Hornchurch, the other side of the River Rom from Dagenham.

Samuel Williams with a group of officials during the construction of Beckton Gasworks. Built on the Thames from 1867 and named after Simon Adams Beck, Governor of the Gas Light and Coke Company, these works were an outstanding success.

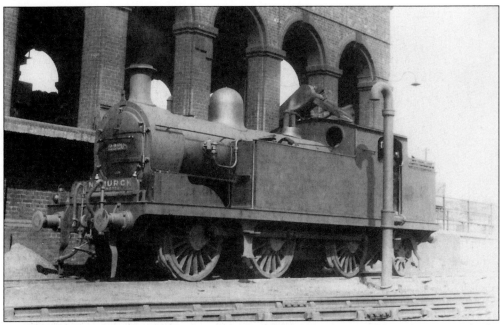

A works locomotive in front of the Victorian grandeur of Beckton – this venture rewards the company for their ambition. The Gas Light and Coke Company soon surpassed its rivals, laying a 48 inch mains to supply London.

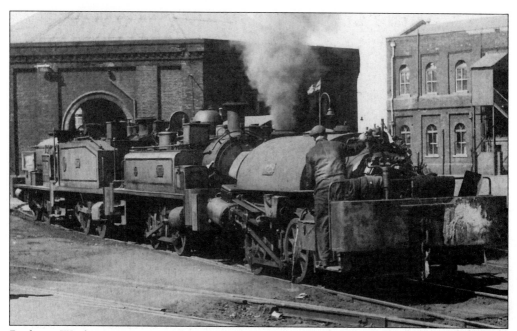

Beckton Works motive power by the locomotive shed after the Second World War. The company had employed several generations of Barking people by the time the works closed in 1976. It had become the largest coal gasworks in the world.

The flaming torches on the coat of arms held by the lions represent Barking's power industries – gas and electricity.

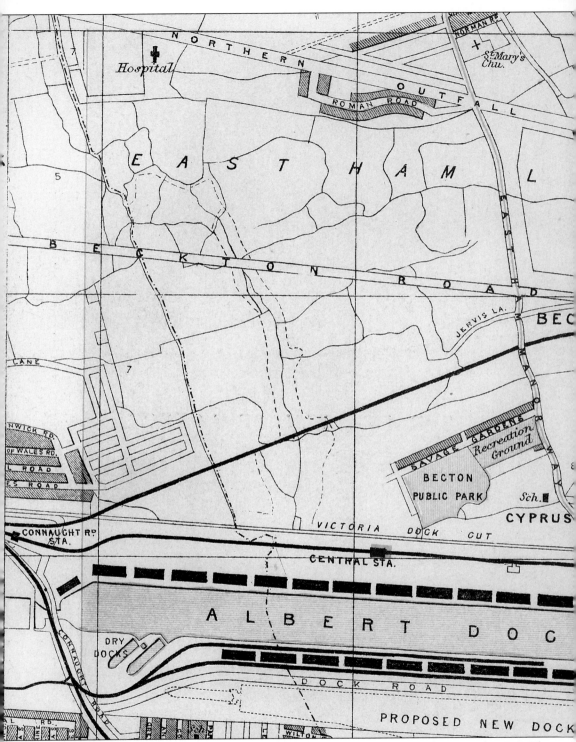

The Beckton area map showing the gasworks, outfall sewer and proposed new Dock, 1913. The complicated geography involved three local government areas, Barking, East Ham & Woolwich, north of the Thames.

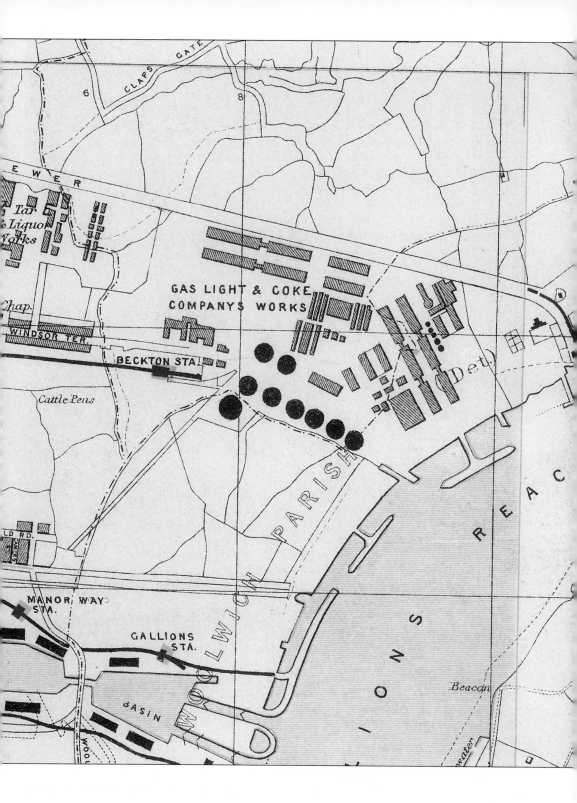

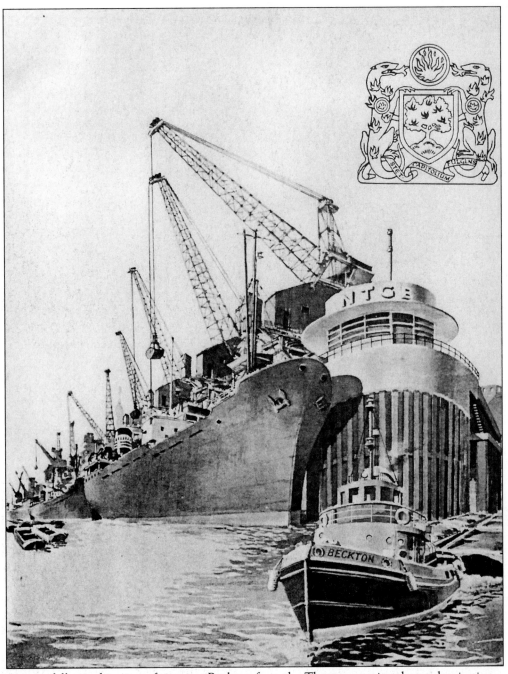

A powerfully graphic view of post-war Beckton from the Thames stressing the modernisation – under the control of the North Thames Gas Board.

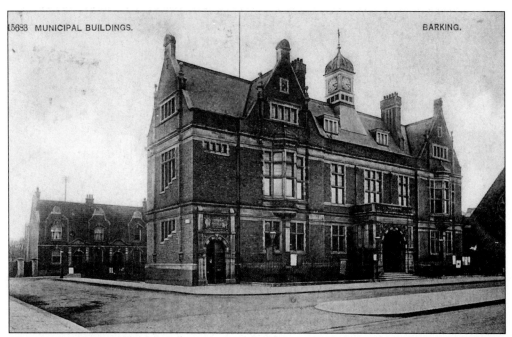

The Municipal Buildings, Barking, 1904. The old Town Hall in East Street, built in 1894 for £12,000, survives as a court house.

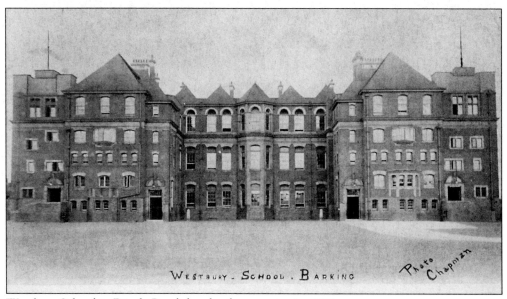

Westbury School in Ripple Road shortly after opening in 1904.

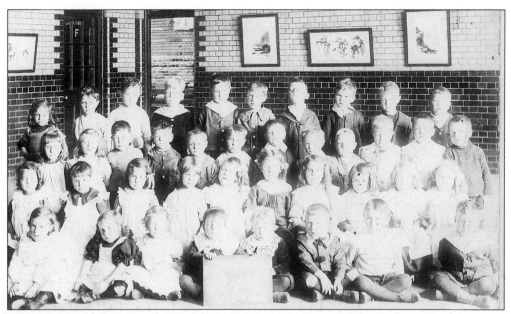

Class of infants from Ripple Road School. Note the typical glazed tile walls and framed illustrations common to schools in the earlier decades of the twentieth century.

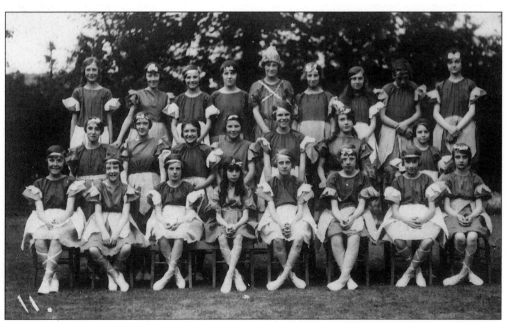

Young ladies of Eastbury School appeared to be dressed up for some form of folk dancing.

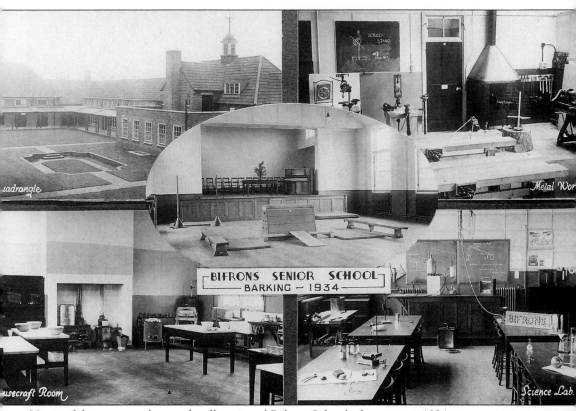

Views of the more modern and well equipped Bifrons School of a new era, 1934.

Early motor car outside the Lodge gates of Barking Recreation Ground, 1906.

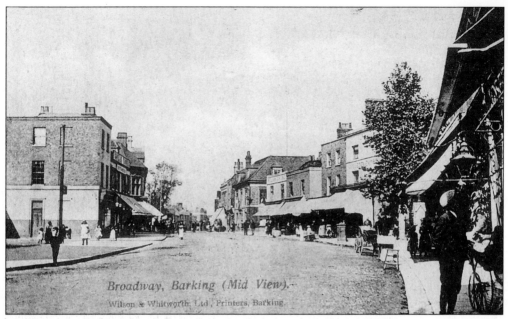

Midway along the Broadway when it was a real centre of activity, c. 1903.

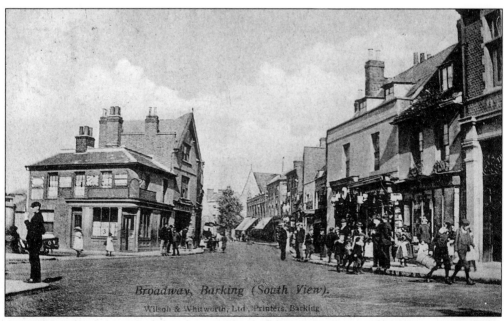

A south view of the Broadway shows older buildings mixed in with Victorian structures, c. 1903.

The Clockhouse – Blake's Corner at the junction of East Street and Ripple Road is seen here around 1916. In directories, Blakes are described as furnishing ironmongers.

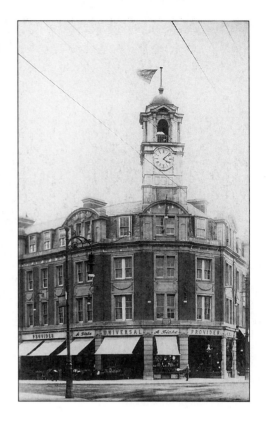

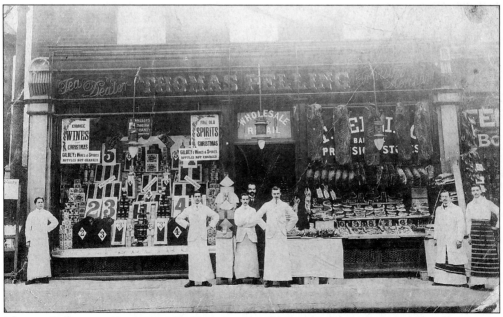

Thomas Pelling – an important Barking grocer and oil and colour merchant. The shop is seen in 1912 with the manager and six of his staff outside on the Broadway.

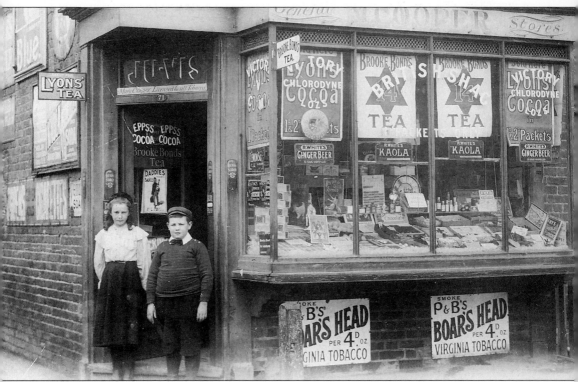

Mary Cooper's corner shop, 71 St Paul's Road – a typical general stores of the period which first appeared in the 1910 directory.

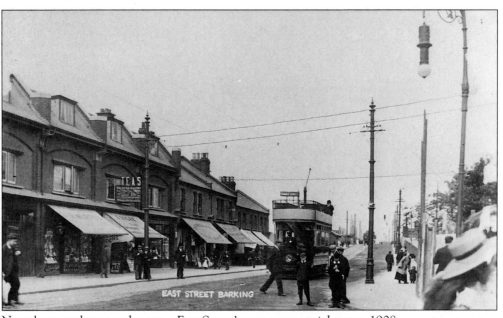

New shops, gaslamps and trams – East Street's new commercial status, 1908.

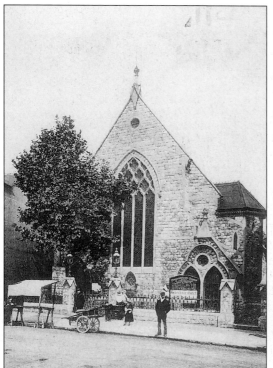

Left: The Revd Henry Arkell was minister of this Congregational church in the Broadway by 1910. This view is from 1904. Right: Revd Hugh Trueman at the Baptist Tabernacle, Linton Road around 1912.

The Church of the Ascension in Tudor Road serving the new Eastbury area of town.

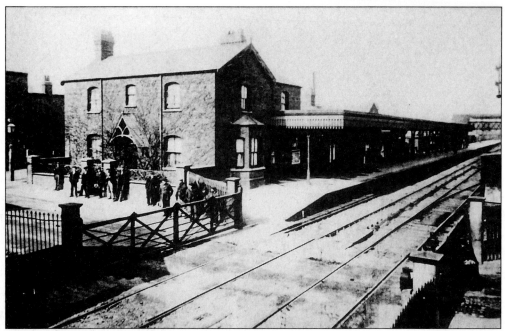

The original station level crossing at the beginning of the century, soon to be replaced by a station bridge and a new entrance.

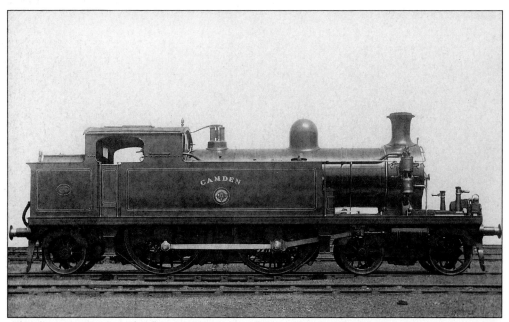

The London Tilbury and Southend Railway's engine – *Camden*. Barking's railway was noted for these locomotives named after stations and places on the line and was always clean and attractively turned out. The railway opened in 1854.

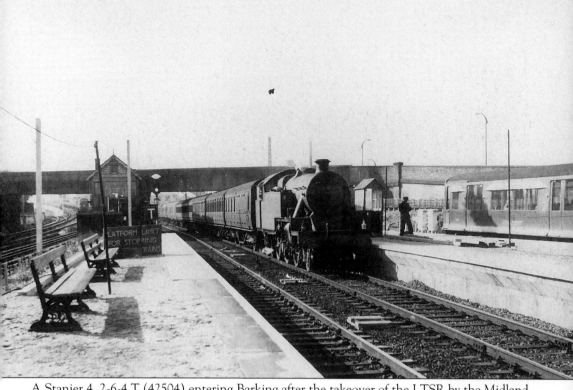

A Stanier 4, 2-6-4 T (42504) entering Barking after the takeover of the LTSR by the Midland Railway.

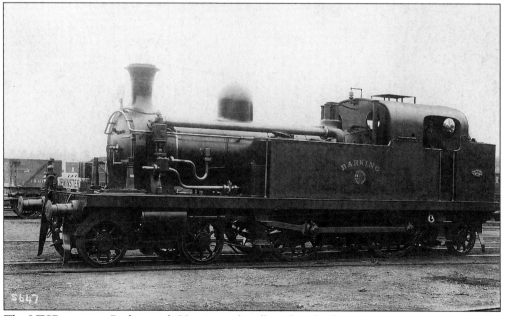

The LTSRs engine, *Barking* with Upminster headboard at the front.

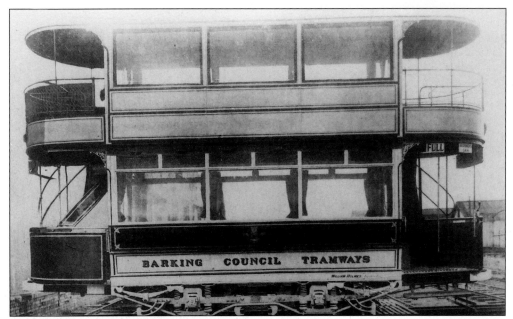
Early trams around 1904.

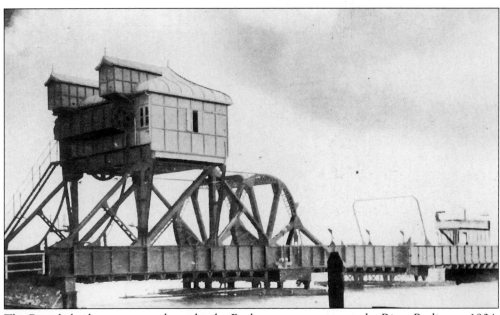
The Bascule bridge constructed to take the Beckton tramway across the River Roding, c. 1904. It could be lifted to allow river traffic through.

An accident to a tram on the windswept line across the marshy Roding banks down to Beckton. This line served the gas and other works which employed a large number of locals.

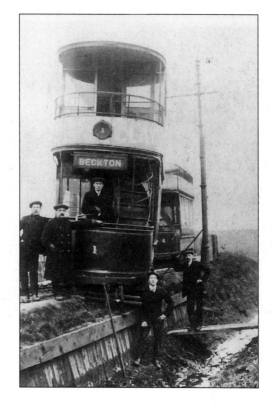

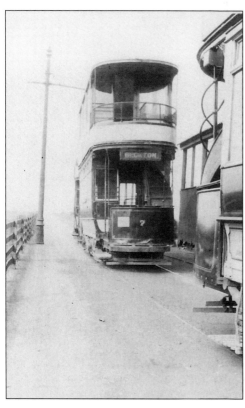

Trams at the Beckton terminus.

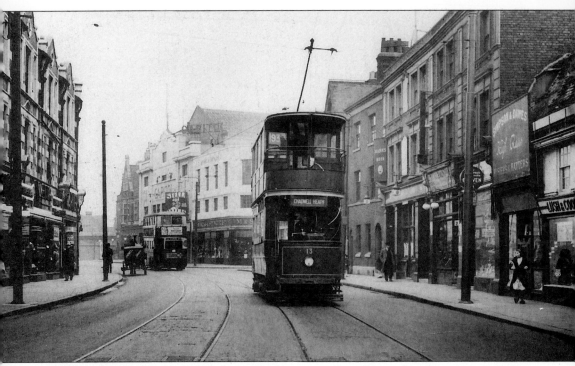

A route 93 to Chadwell Heath tram waiting in East Street for the return journey in January 1938.

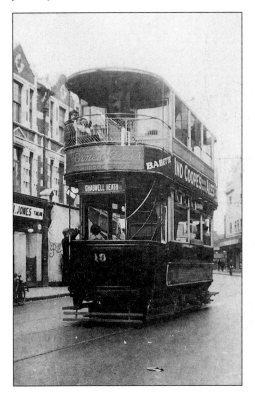

An Ilford Corporation tram in East Street on the 21 August 1933, on the Chadwell Heath service. The London Passenger Transport Board was soon to take over all these local services in the London area.

A humorous poster used to attract attention on buses running to Barking.

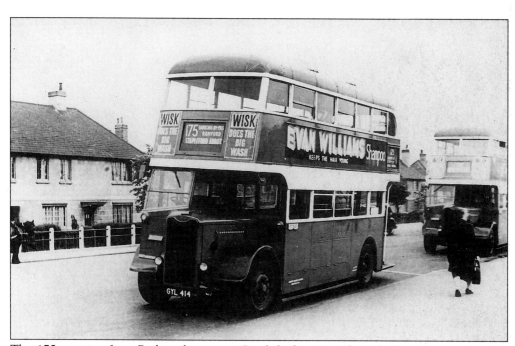

The 175 running from Barking by-pass to Stapleford passing through Dagenham on its way to Romford.

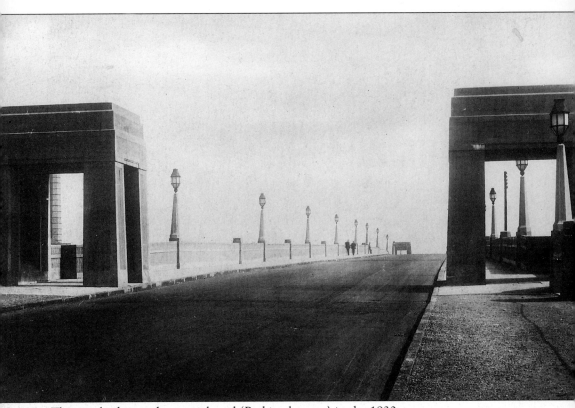

The new bridge on the arterial road (Barking by-pass) in the 1930s.

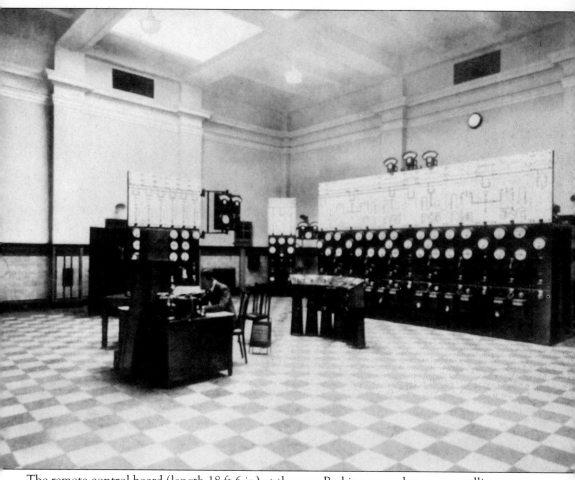

The remote control board (length 18 ft 6 in) at the new Barking power house, controlling over 125,000 horsepower, in 1925.

The wharfside at Barking power station, 1925, showing a busy scene at the jetty with a steamer alongside together with cranes and the power station rail line. The new power house, as it was then called, situated at Creekmouth, was officially opened by King George V on 19 May 1925 for the County of London Electric Supply Co. Ltd.

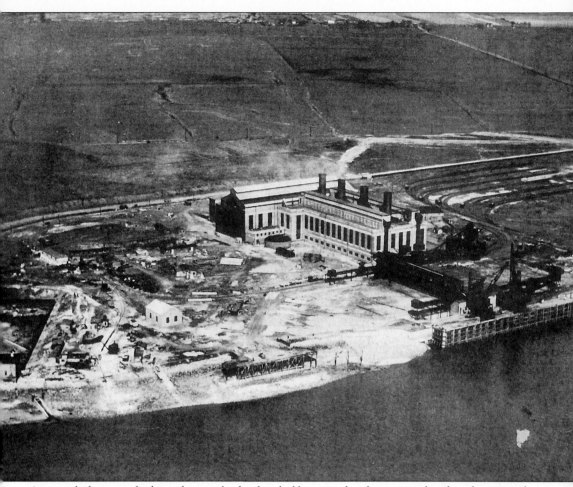

An aerial photograph shows how only the first half-section has been completed at the time of opening. The intended capacity of the power station when complete was to be over 750,000 horsepower, to use the quaint technical description of 1925.

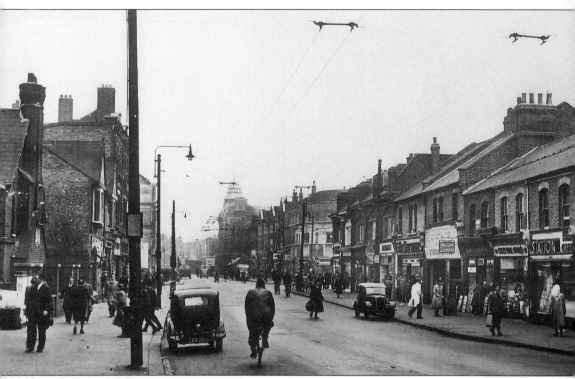

East Street, Barking in the 1930s. There are only bicycles and a few cars in view. Blake's Corner is on the horizon.

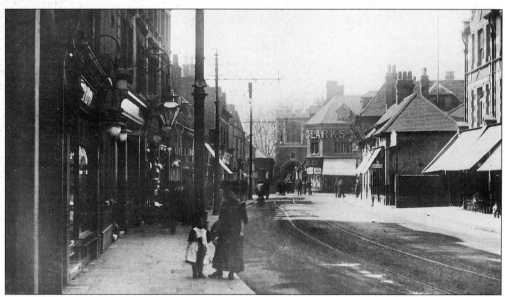

The Broadway end of East Street in 1908 with Clark's Stores in the Broadway junction near North Street and the Curfew Tower in the middle distance.

Four
Work and Leisure Town

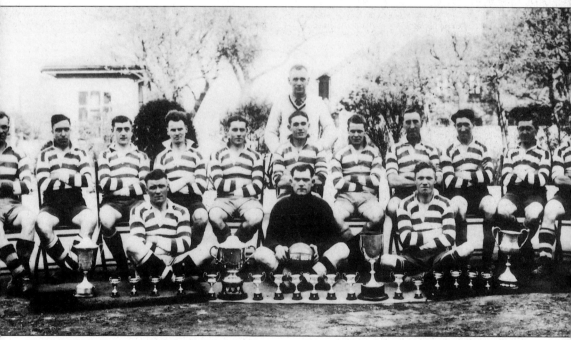

Beckton Gas Works. A powerful competitor to the new electricity suppliers, gas was still used to light many homes through the old fashioned and fragile gas mantles which often needed replacement. Barking's newer homes began to be built with electric for lighting and cooking. Coal was still a favoured source of heating through to the mid-twentieth century. The jobs of the many Barkingonians at Beckton were however secure for decades to come as the station supplied gas for millions in the older houses in inner London and many new houses used gas for cooking.

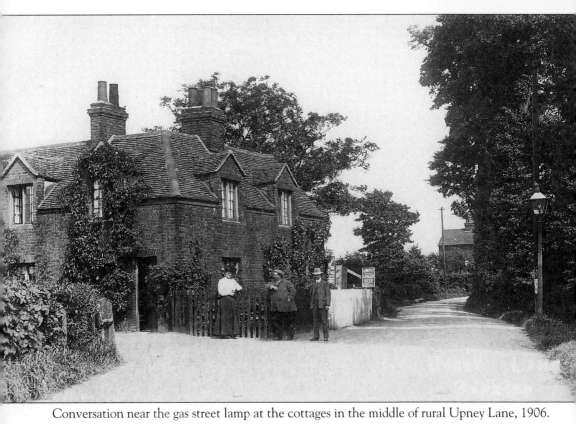

Conversation near the gas street lamp at the cottages in the middle of rural Upney Lane, 1906.

Barking windmill stood on the west side of the town with a few houses nearby.

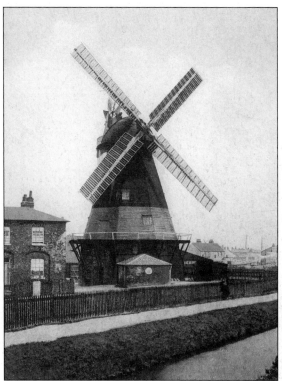

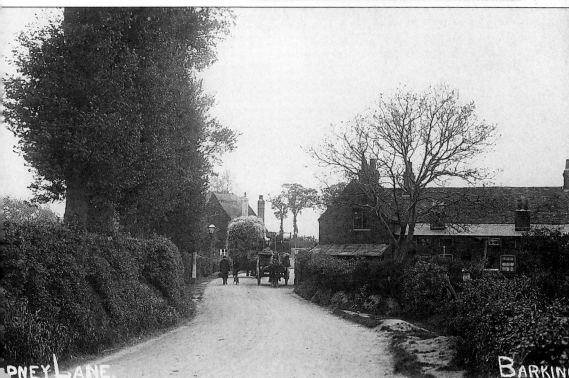

A load of hay is carted along Upney Lane, 1909.

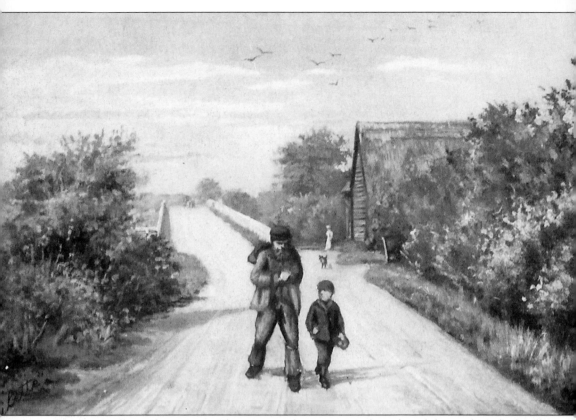

Out for a walk in Choats Lane. The man may be going to seek work with his tools in the bindle, while the youngster is probably going to school.

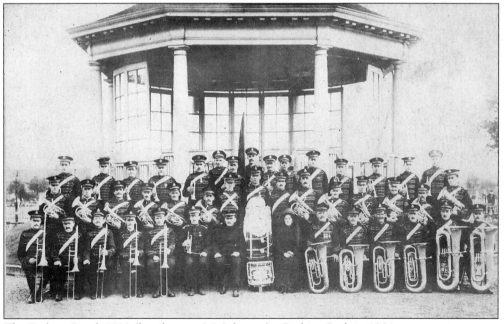

The Barking Band, 1922 (bandmaster Mr Johnson) a Barking Park in 1921.

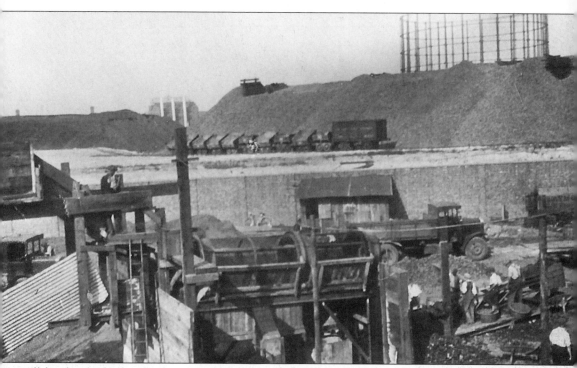

All kinds of subsidiary industries and businesses flourished around Beckton. This is Ferndale Depot which supplied washed and graded clinker for filter beds. Note the working gear of shirts and waistcoats in the 1930s.

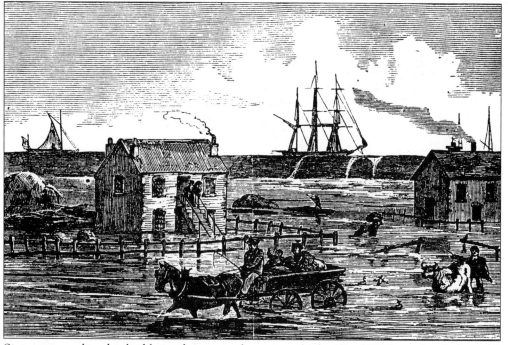

Sixty years earlier this had been the scene after a great high tide of 1874 – a sketch from the *Pictorial World* of 28 March.

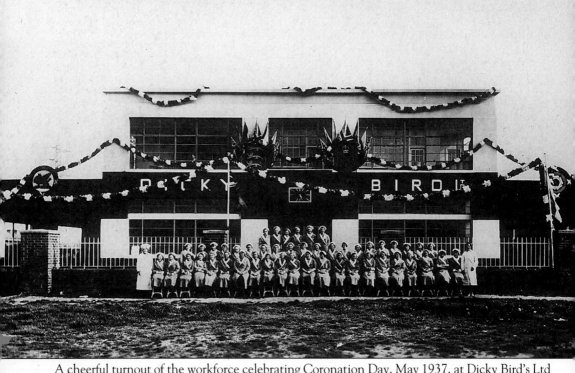

A cheerful turnout of the workforce celebrating Coronation Day, May 1937, at Dicky Bird's Ltd on the Barking by-pass.

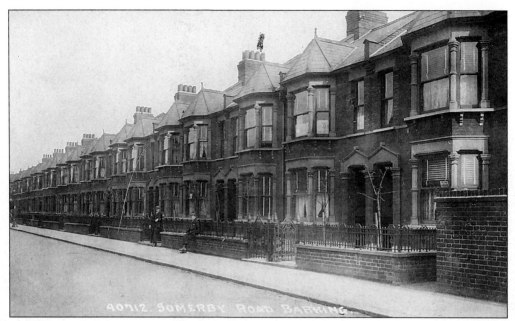

Somerby Road with its Victorian style houses, in 1909.

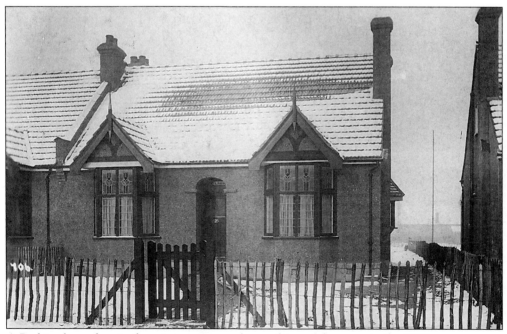

A Barking bungalow in the winter snow on the outskirts of the town in the 1920s.

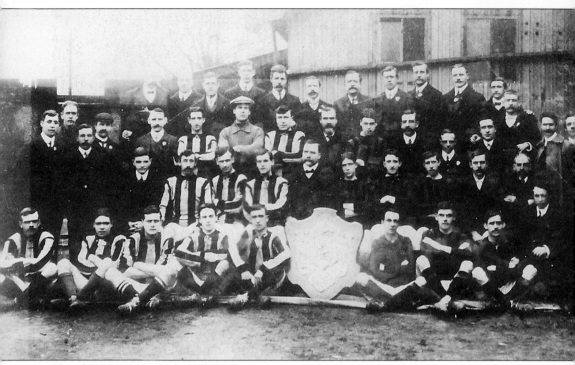

The famous Barking Football Club – a team of 1909/10. They were joint champions of the London League Division One in this year. In 1920/1, as Barking Town, they were London League champions.

Barking's playground 1920 – a view of the lake.

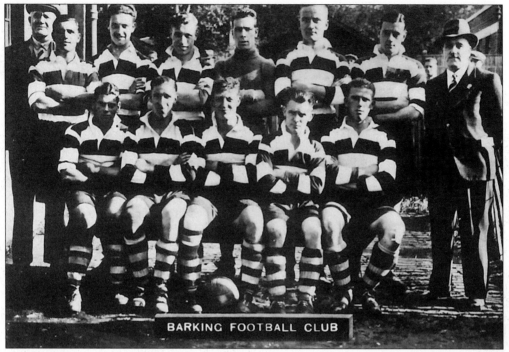

BARKING FOOTBALL CLUB

A Barking Football Club team of the late 1930s. They lost to Exeter City (away) 0-6 in the first round of the FA Cup in 1928/9, but have succeeded in reaching the second round on several occasions.

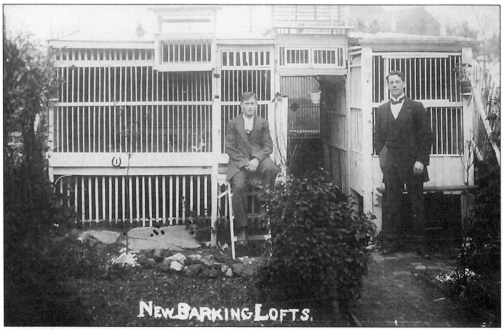

NEW BARKING LOFTS.

Proud pigeon-racers outside the new Barking lofts just before the First World War. Did these men survive through to peacetime in 1919?

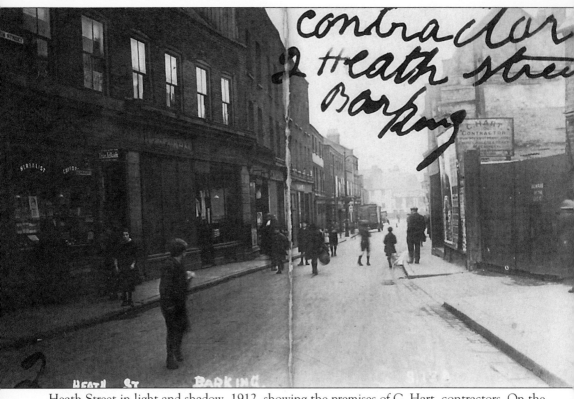

Heath Street in light and shadow, 1912, showing the premises of C. Hart, contractors. On the way dow to the Quay and Beckton, this street was a hive of working-class and commercial activity.

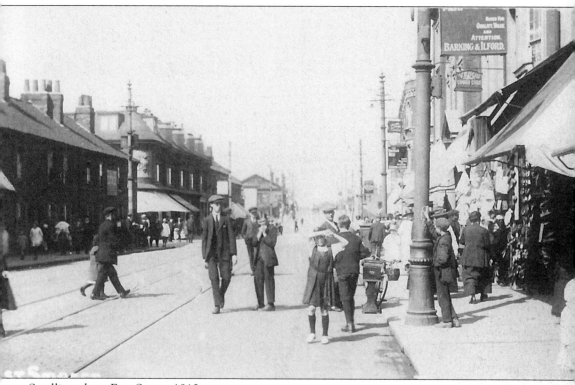

Strolling along East Street, 1912.

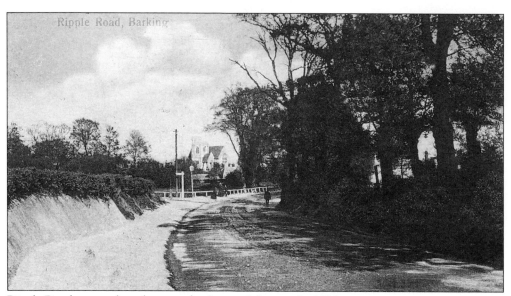

Ripple Road – a rural roadway on the fringe of the marsh, 1908.

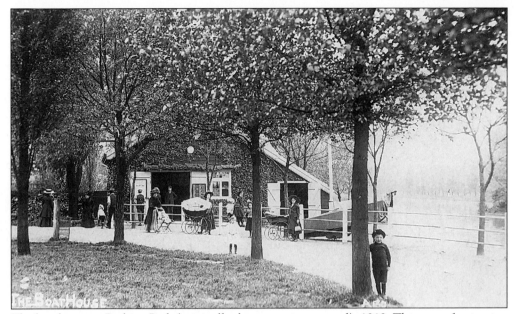

The boathouse at Barking Park (originally the recreation ground), 1912. This was a fascinating place for children in the days when they might disappear to the park for a whole day without causing their parents worry.

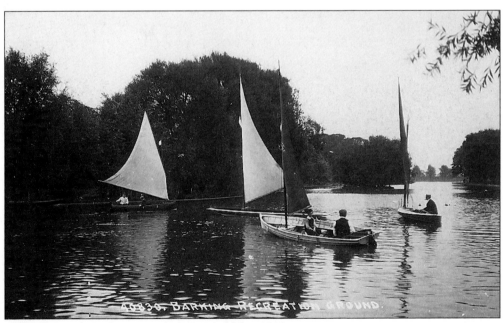

Sailing boats on Barking recreation ground lake, 1919.

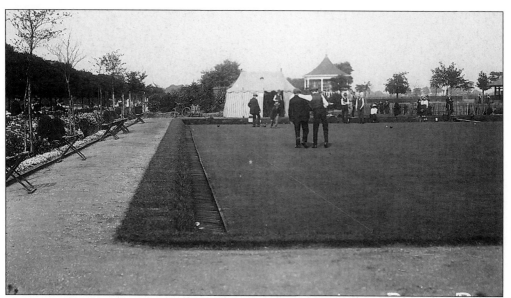

The neat and tidy bowling green in Barking recreation ground, 1914.

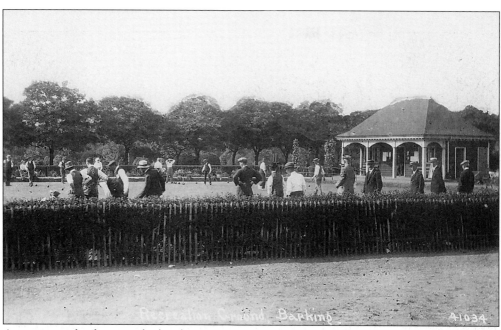

A view over the fence to the bowling green in 1924. Bowling was a popular hobby that helped some forget the horrors of the First World War.

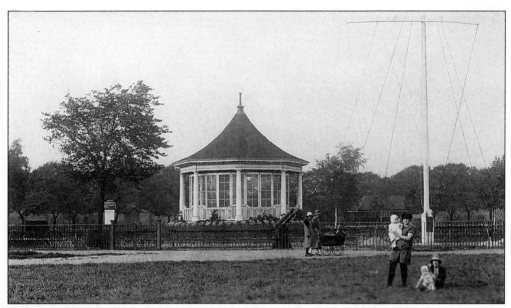

The bandstand in Barking Park in the 1930s. This was once a very important part of the park's amenities. Henderson, a local firm, fitted it with a set of their special sliding doors.

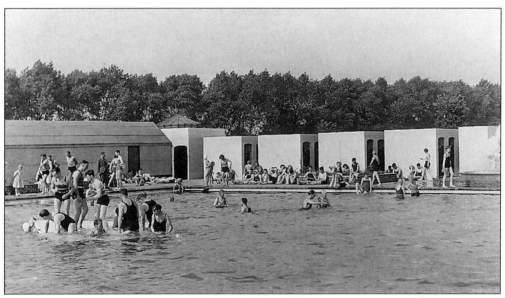

The park also had this well patronised swimming pool (lido style), seen in around 1936.

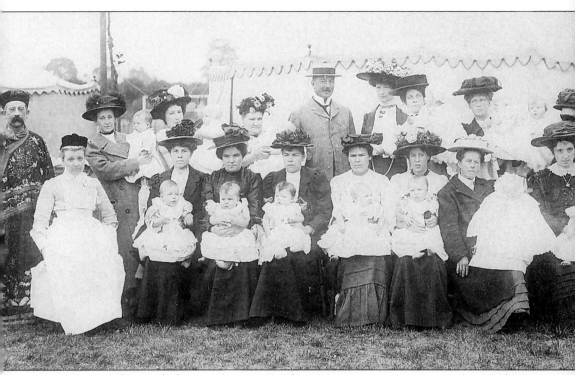

Carnival prize babies with their mothers, 1909. There were some exciting carnivals in Barking around this time. Many of the locals were not well off and they put on a show for which they had saved all year.

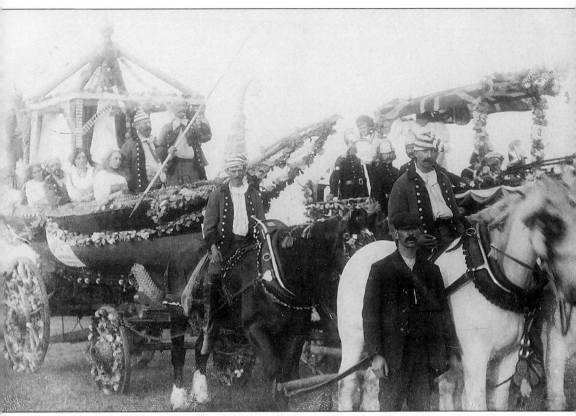

An entry for the best decorated float in the 1908 carnival. One of those who took part was under no illusions about her float and wrote of the exhibit shown, 'supposed to be the Gondoliers – looked more like a Wild West Show – we got fourth prize'.

Five
Old Dagenham Village

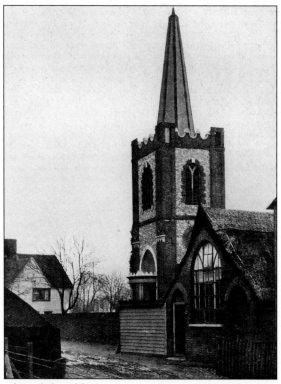

A glimpse of the church and the old structure nearby, once near the centre of the little village, around 1908. The buildings which once surrounded the church have mostly been demolished and the area is now a back water of modern Dagenham. Only the Cross Keys Inn to the north (dating from the fifteenth century) across Crown Street hints at the wealth of timber-framing which gave old Dagenham its charm. A vicarage next door, though altered, still retained work from the seventeenth century. One could imagine smugglers ghosting through the churchyard in the old days with their booty of kegs and containers. In fact this plot contains the grave of an early police constable who was murdered, probably because he fell foul of smugglers.

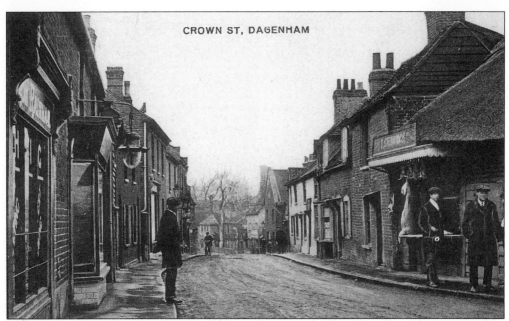

CROWN ST, DAGENHAM

The east end of Crown Street with an old style butchers on the right and a pitted road surface.

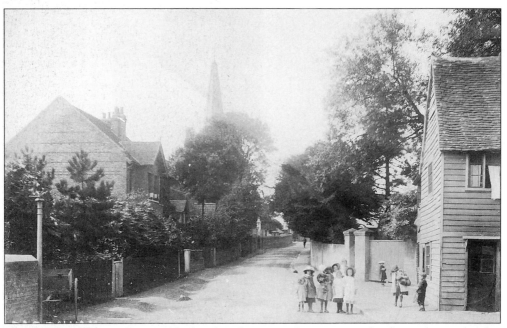

The middle of Crown Street with the church spire and vicarage garden beyond provides this peaceful scene, with a tribe of local children grouped beside a vernacular timber-clad dwelling.

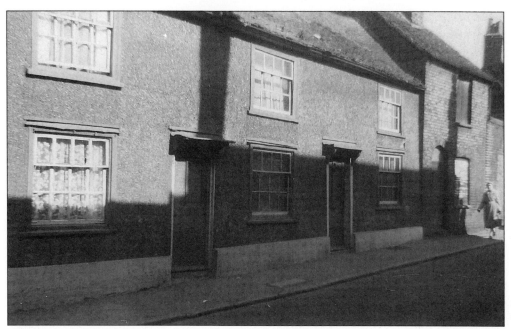

The former Rose and Crown Inn, Crown Street still surviving in 1963.

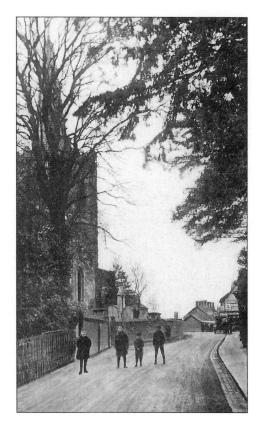

A side view of St Peter and St Paul parish church from Crown Street with the Cross Keys Inn on the right behind the trees.

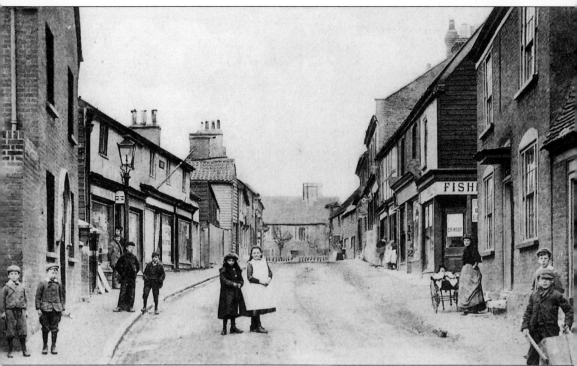

On the back of this view of this east end of Crown Street has been written, 'This is the principal street', *c.* 1905.

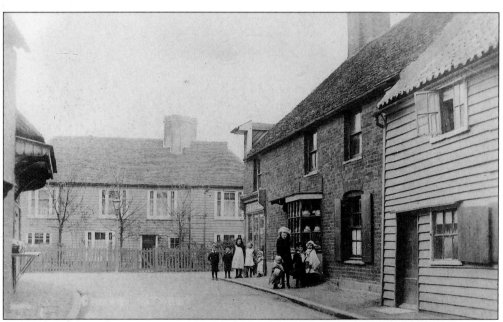

Looking out from Crown Street towards the then Bull Street. The butcher's shop on the left, two other shop windows and a timber dwelling on the right carry us back to another age.

Another view of Dagenham parish church showing clearly the rubble boundary wall, the distinctive porch and the spire which it later lost. This view is from the early 1900s.

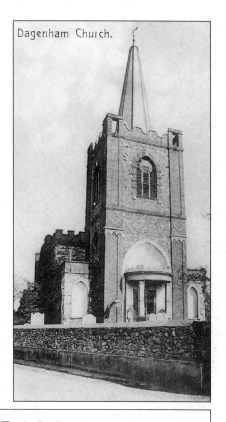
Dagenham Church.

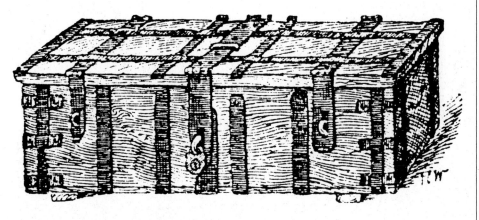

DAGENHAM.

Sts. Peter & Paul.

Length 3ft. 5in., width 1ft. 6in., depth 1ft. 4½in.

This delightful chest with its old protective iron bands and locks belonged to the parish church.

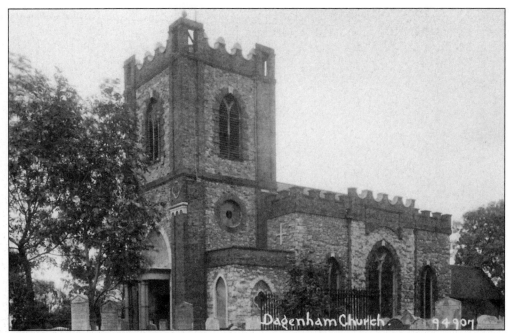

A view of Dagenham church with its spire removed due to dilapidation, in the 1920s.

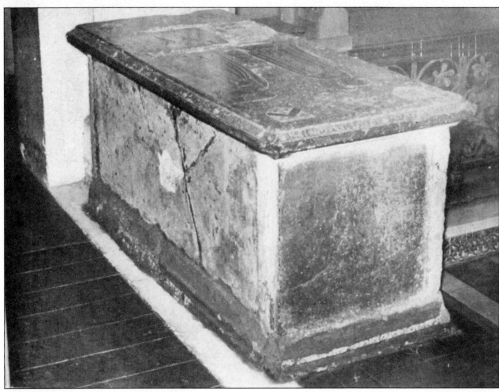

The Urswick tomb looking as if it has survived many vicissitudes. This bears a brass of Sir Thomas Urswick, once one of Dagenham's most powerful men.

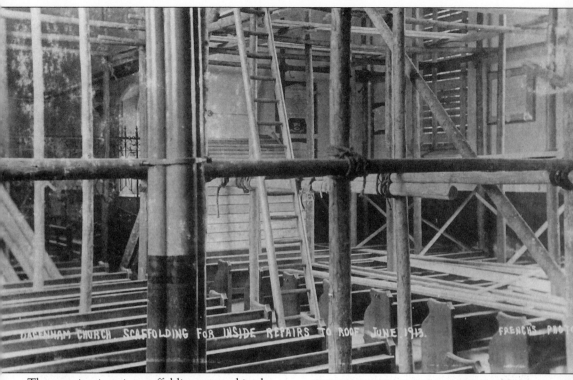

The amazing interior scaffolding erected in the parish church during repairs to the roof in June 1913.

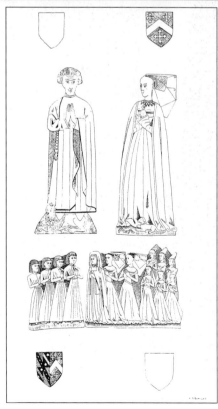

The Urswick Brass in Dagenham church.

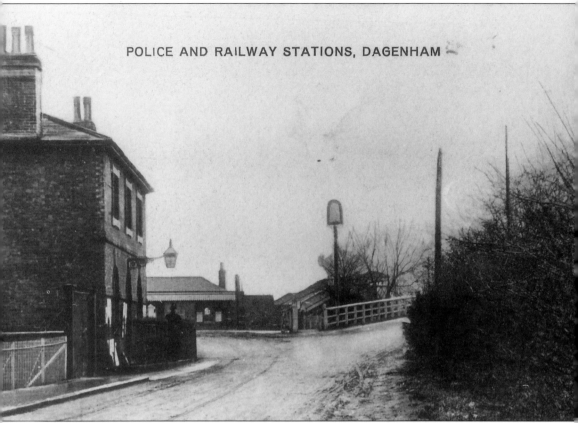

The police and railway stations in 1908.

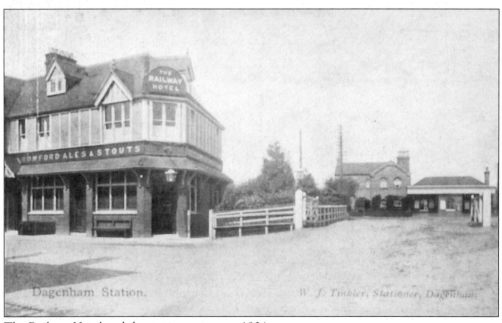

The Railway Hotel and the station entrance, 1904.

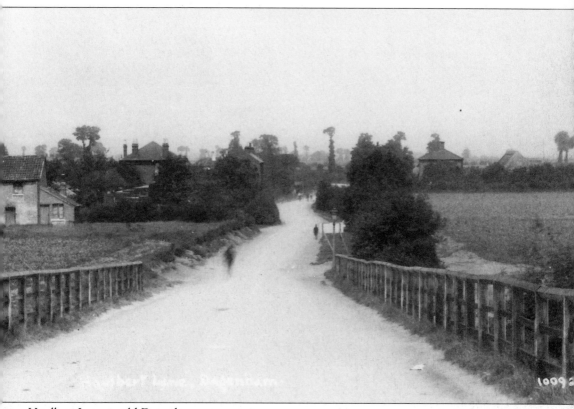

Haulbert Lane in old Dagenham

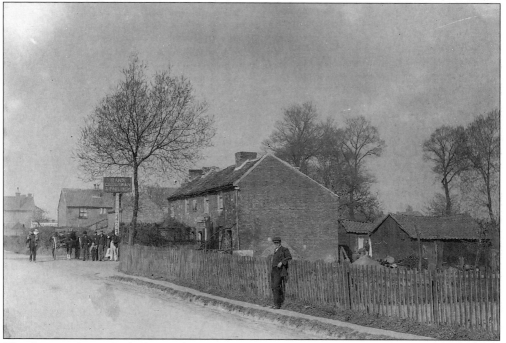

The Coopers Arms, Rush Green about 1900.

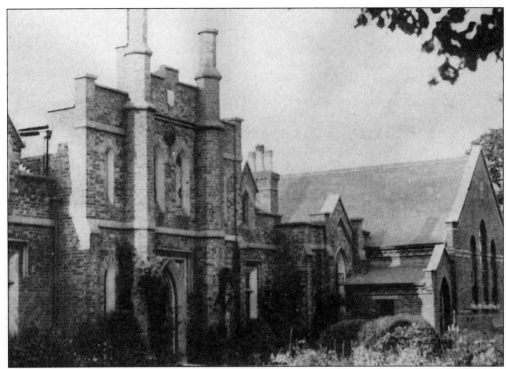

The Ford Endowed School was founded by William Ford, a Dagenham farmer who died in 1825 leaving £10,000. Opened in 1841, it was extended by the time this photograph of 1895 was taken.

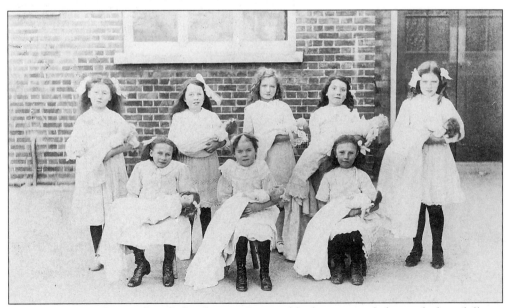

Children of Dagenham Village School, 1914. Presumably these young ladies with their dolls are learning mothercraft.

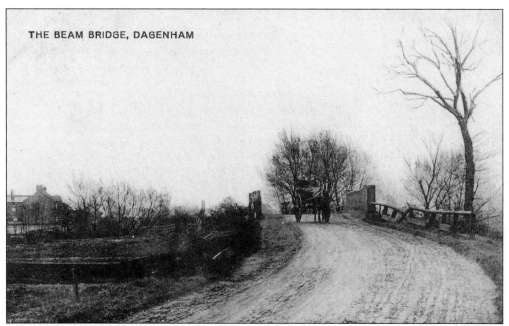

THE BEAM BRIDGE, DAGENHAM

Beam bridge – a very quiet spot in 1912 with only one cart in view going about its business.

STOLEN or STRAY'D,
Out of the Grounds of the Farm next to the Sign of the Bull in Dagenham in Essex, a brown Mare about Five Years old, 14 Hands high, a long Switch Tail, with a little Slit in one of her Ears. Whoever gives Notice of the said Mare to Henry Humphrey at the Farm House abovementioned, or to Mr. John Fell, jun at the Wine Vaults, Wapping New Stairs, shall receive One Guinea Reward. N B. The above Mare has been Colt about three Months.

1730

Thursday, last Week, was the greatest Spring Tide that has been these 50 Years, the Water running 6 Inches higher than at the extraordinary Tide which occasion'd the Breach at Dagenham, by which an incredible Damage was done on the Banks of the River Thames, by overflowing several Dock-Yards.

1731

Brick-burner.—William Robinson, jun. of Dagenham in Essex, Salesman.—Isaac Took,

1747

Eighteenth-century newscuttings about Dagenham give us an insight into daily life in the quiet village.

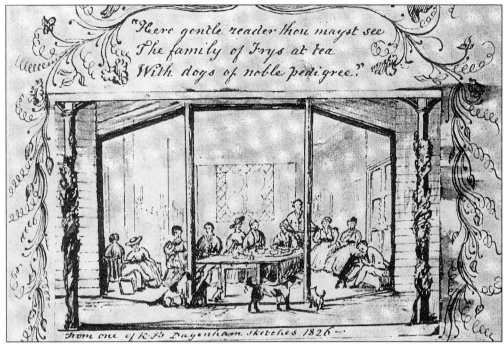

"Here gentle reader thou mayst see
The family of Frys at tea
With dogs of noble pedigree."

from one of K.F's Dagenham sketches 1826

The famous Elizabeth Fry's family spent some happy days in Dagenham Breach during the 1820s while they were in somewhat straitened circumstances. Living in simple cottages on the fringe of the Gulf and away from it all, some incidents were recorded by Elizabeth's sister, Katharine, who drew this scene of the Frys at tea, 1826.

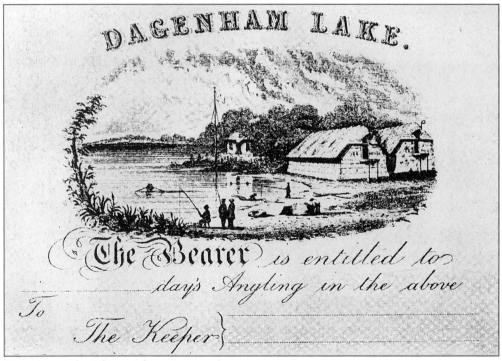

DAGENHAM LAKE.

The Bearer is entitled to day's Angling in the above

To

The Keeper}

Dagenham Lake fishing ticket, nineteenth century.

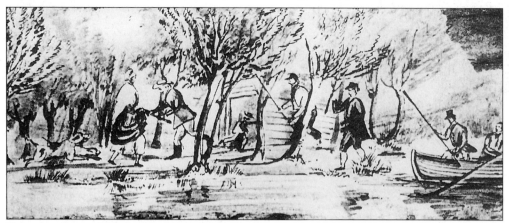

Fishing at Bream Island – Mrs Fry is chased by fierce dogs!

Almost a century later Dagenham Gulf is still a popular country fishing resort. Anglers are seen taking refreshment in 1913.

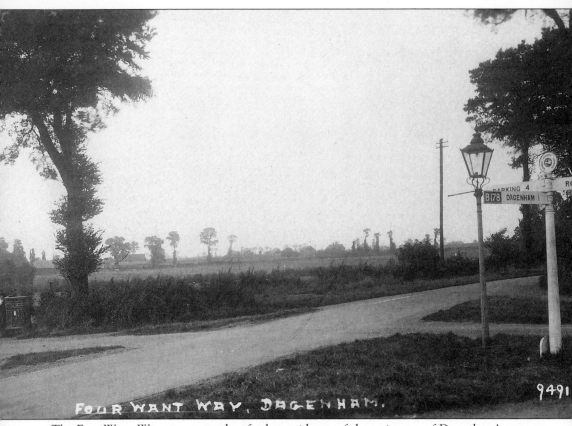

FOUR WANT WAY, DAGENHAM.

9491

The Four Want Way or crossroads – further evidence of the quietness of Dagenham's country lanes before the arrival of the Becontree Estate and Ford Motor Company. The area at the junction of Oxlow Lane, Dagenham Road.

Opposite: Plan of Hunter's Hall Farm, 1739. Many documents of this kind have survived to give clues to the past of Dagenham. From the opening of Dagenham public library in 1926, librarians have copied items from many other archives to build up a record of the area's past.

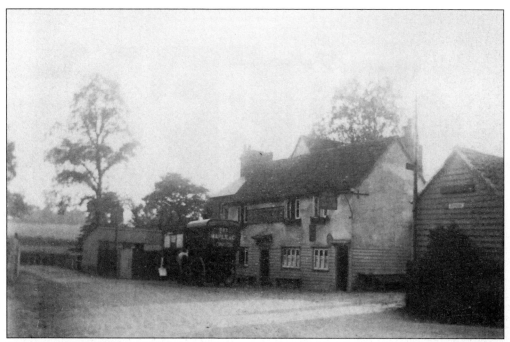

An old view of the Merry Fiddlers public house in the 1900s, complete with Harrods van. One wonders what it had brought.

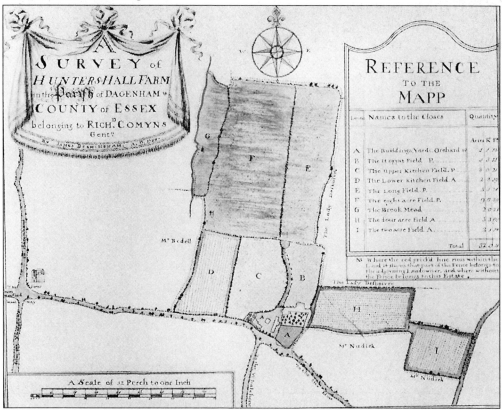

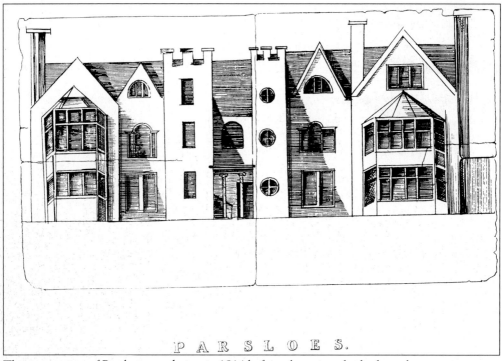

PARSLOES.

This impression of Parsloes was drawn in 1814 before alterations had taken place.

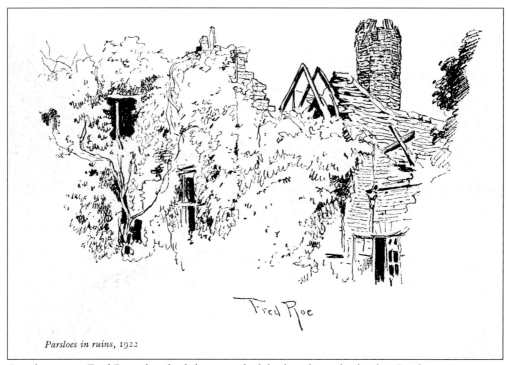

Parsloes in ruins, 1922

Another artist, Fred Roe, sketched this record of the last days of a derelict Parsloes.

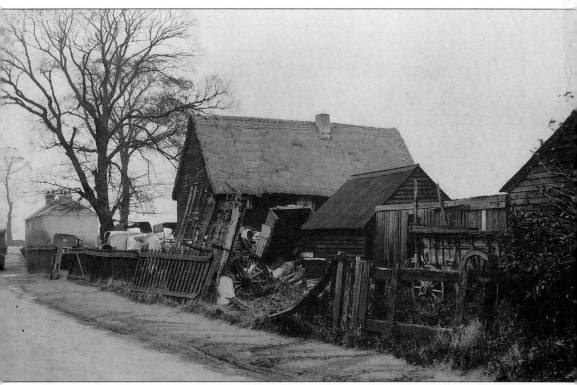

Eastbrook Farm, Dagenham, *c.* 1930. Finally demolished in May 1931, it was still surrounded by farmland in 1914 and many other farms such as Wonts Farm at the Four Want Way, Frizland, Sermons and Brown's farms.

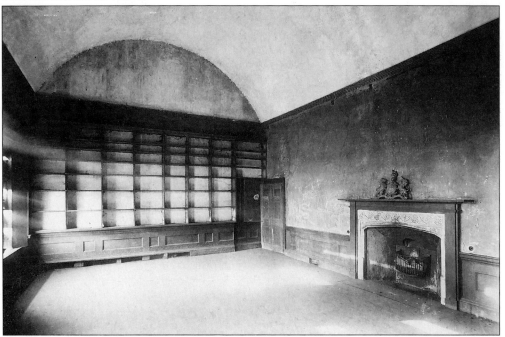

The library at Parsloe House after it had become empty.

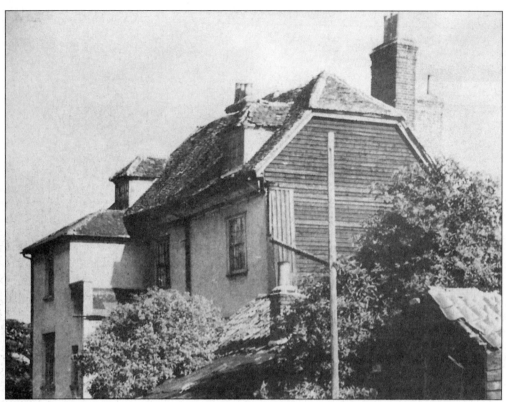

Eastbrookend farmhouse was an L-shaped late-seventeenth-century structure which had succeeded many others standing on the same site, at least back to the thirteenth century.

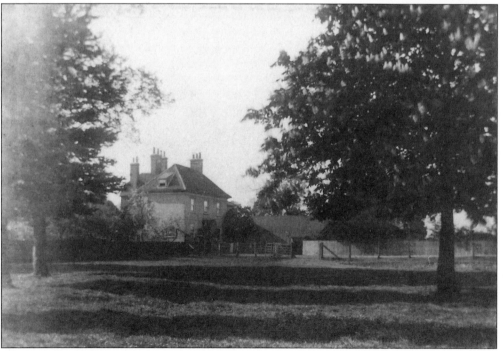

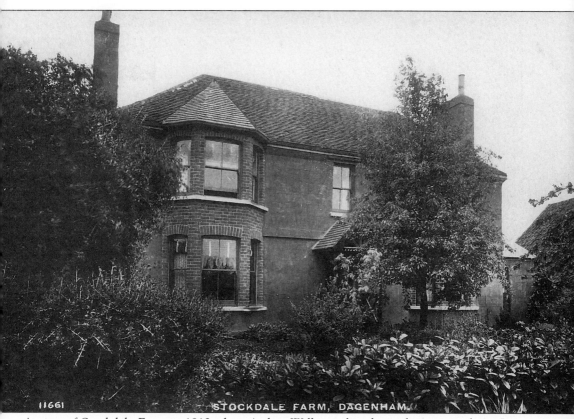

11661　STOCKDALE FARM, DAGENHAM

A view of Stockdale Farm in 1912 when Arthur Wilkin is listed as a fruit grower here. It is marked as Stock Dull on the 1777 map but can be traced back to Thomas Stokdale in 1456.

Opposite: Eastbrookend House at the turn of the century belonging to Mr Currie. By 1908 a Mrs Elizabeth Currie is listed as a farmer at Eastbrook End. The name is mentioned in land revenue books of 1609.

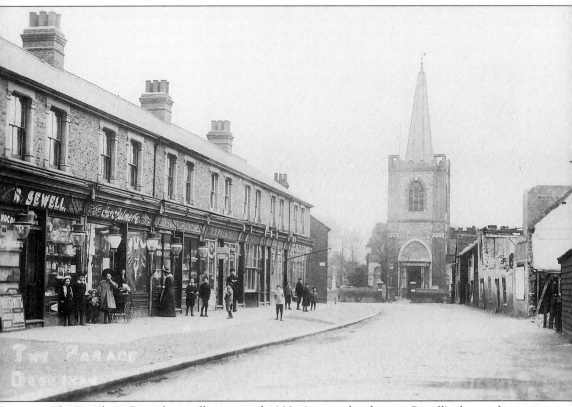

The Parade in Dagenham village around 1908. Among the shops is Sewell's the confectioners at No. 7.

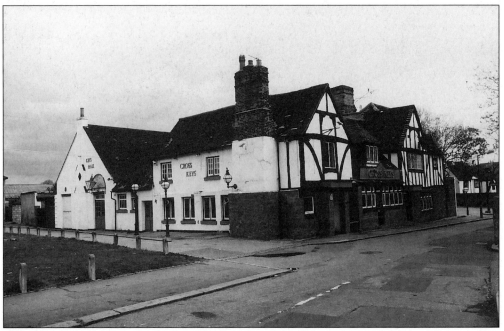

The Cross Keys public house by the church – one of the few survivors of old Dagenham.

Six

The Riverside
and the Rise of Ford's

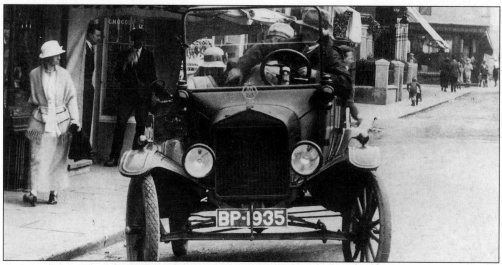

An example of an early Ford motorcar, registration, BP 1935. Ford's factory could never have been built on the Dagenham Marshes without the help of pioneering firms who had prepared the site. Samuel Williams was an apprenticed lighterman who began his own business in 1855. He then purchased some acres of riverside marsh at Dagenham in 1887 and commenced the construction of Dagenham Dock. His firm (Samuel died in 1899) built up the marshland and created an infrastructure which eventually made possible the location of much industry on these once wild, windswept, inhospitable levels. Trenthans were selected to construct the Ford Works, having bought the site of over 300 acres in 1924. Several years elapsed before the piles on which the works would rest were laid out and driven into the ground by the old steam driven pile-drivers. The area resembled a giant pincushion as the pile-heads protruded from the marsh over large areas of land. Work began in 1929 and soon coke ovens, a power house, blast furnace and an assembly building with two blast foundries and car part manufactories arose on the site.

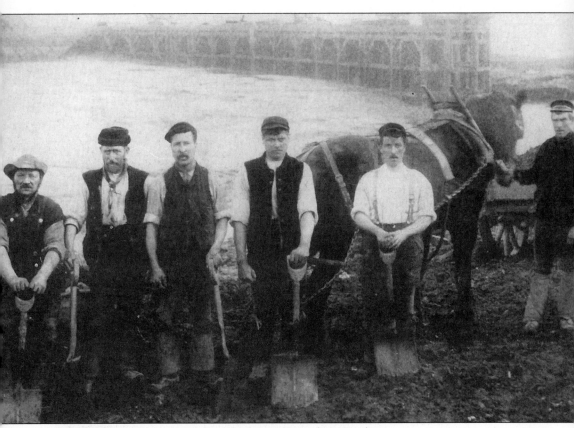

Building the wooden west wall of the basin, Dagenham Docks.

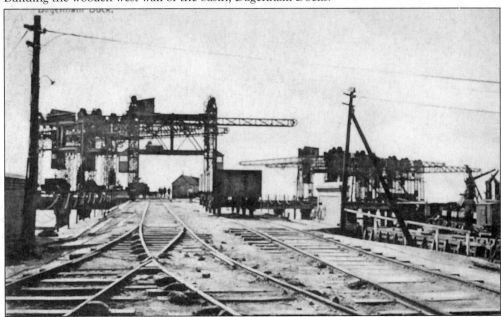

Samuel Williams' Dagenham Dock in 1906 showing the efficient railway network and the electric transporter cranes on the jetties.

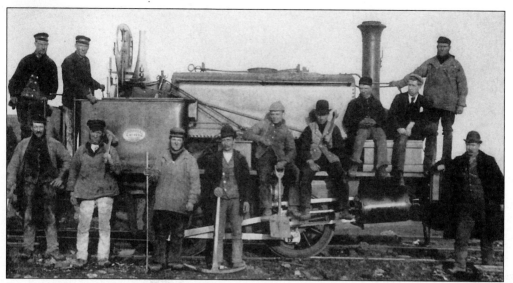

Samuel Williams' locomotive No.2 which was sold in 1947.

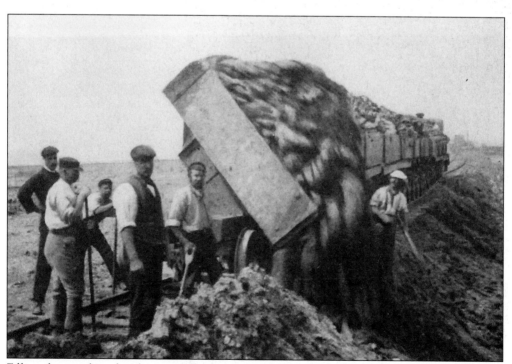

Filling the marsh with side-tipping wagons.

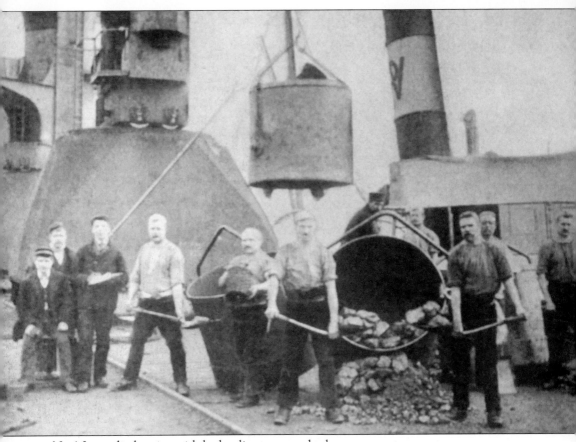

No.1 Jetty, discharging with hydraulic cranes and tubs.

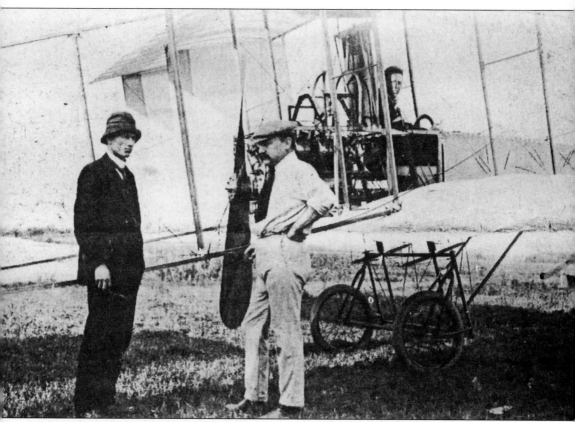

A.J. Roberts and Major Baden-Powell talking powered flight, *c.* 1909. The site of part of today's Ford Works actually formed Britain's first flying ground for experiments with early planes. Led by Baden-Powell, brother of the Chief Scout, members of the Aeronautical Society of Great Britain tried out early biplanes. The thistle covered marshland was immediately to the east of Dagenham Docks – it had only recently been reclaimed by depositing clay excavated in the construction of London's early underground railways. The aircraft shown never actually flew although it ran along the ground at good speed.

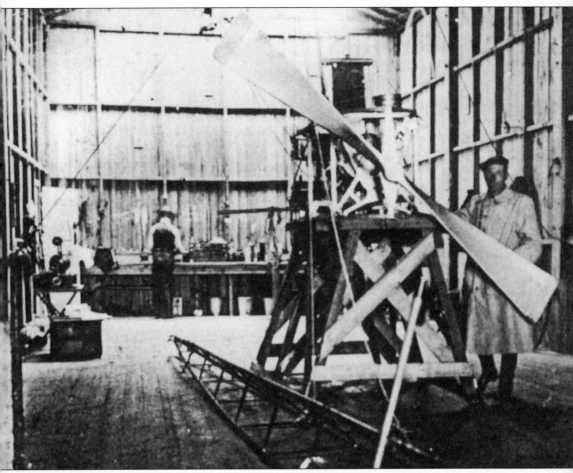

In 1910 the propeller and engine of a radio-controlled airship are tuned up by engineers in the large wooden hangar on the marsh. The hangar had been constructed by the Dagenham village firm of West and Coe whose carpentry skills are still employed in their undertaking business. Again the tests were abortive, the airship rising a few feet in the air before being badly damaged. All that can be said was that some information was gained which was put to use later on.

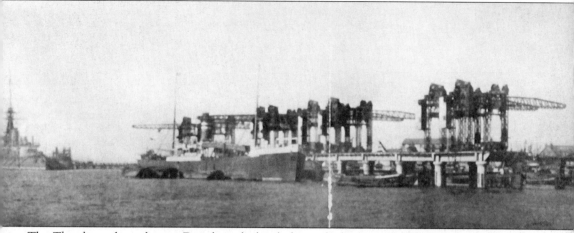

The *Thunderer*, the only iron Dreadnought battleship to be built on the Thames, was built and launched at Canning Town and towed to a special jetty constructed by Samuel Williams to be fitted out. Forever after the jetty was known by the name of the Thunderer. This photograph dates from 1911.

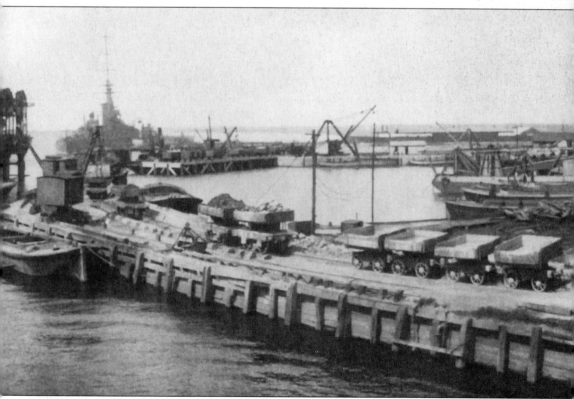

Another view of HMS *Thunderer* being fitted out while a dredger lies in the basin nearby.

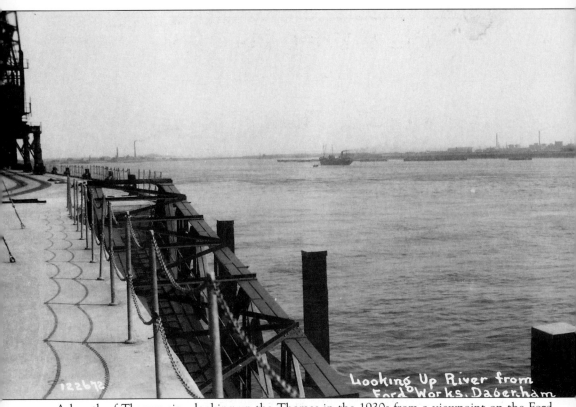

Looking Up River from
Ford Works, Dagenham

A breath of Thames air – looking up the Thames in the 1930s from a viewpoint on the Ford river frontage.

NEW FORD BEAUTY

NOW ADDED TO

FORD PERFORMANCE

The Coupé, £215 at Works, Manchester

To the fine performance and quality of the new Ford is now added a new beauty.

The many new features have been introduced in accordance with Ford policy, with no increase in price.

New roomy bodies. New rustless steel. New deeper radiator. New larger mudguards. New smaller wheels and larger tyres. New streamline moulding. New colours.

Call in at our showrooms to-day. See for yourself these beautiful new Ford bodies. See what new beauty and distinction has now been brought within the reach of all. Come early to-day.

LINCOLN Ford Fordson

Reynolds FOR Fords
FACILITIES AND SERVICE

Advertisement for the Ford Coupe in April 1930. This came from the works at Manchester – the UK headquarters before Dagenham. Cars of all types were soon to be rolling off the Thames marshes plant production line.

103

THAT EARLY THRILL RECAPTURED !

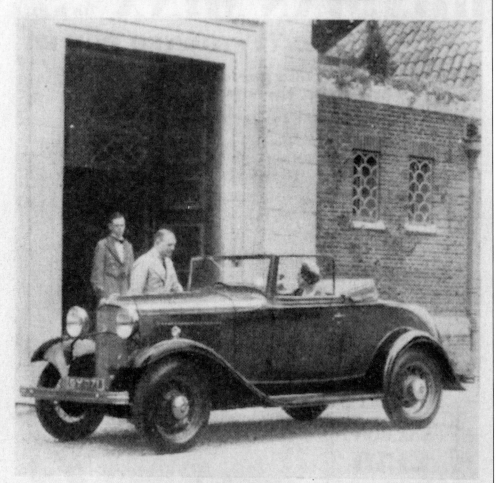

THE FORD V-8 CABRIOLET

Do you remember times when every drive had a thrill, " a kick in it " ? Long while ago, but this Ford V-8 has recreated that state of affairs. The more experienced, the more blasé, you have become, the more you will enjoy the use of the car which all but thinks for you. Pace ? All that is safely used under modern conditions. Noiselessness ? Of a degree that gives the word a new meaning. Yet no car of comparable performance—to ignore performance *refinement*—costs so little, to buy or to run ! Ask the local Ford dealer for a fully descriptive booklet giving the surprisingly low prices. Ask him to arrange a road test.

FORD MOTOR COMPANY LIMITED
LONDON AND DAGENHAM

The Ford V8 Cabriolet advertisement now bears the address London and Dagenham, 1933.

DAGENHAM, ESSEX,
Supplies the world with the
8 H.P. FORD

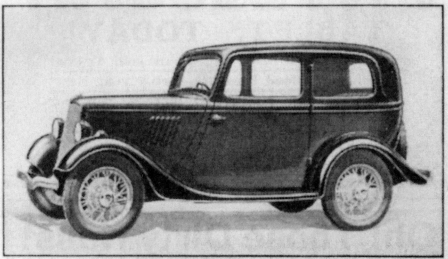

Ford 8 h.p. Saloon (2 Doors), £120, at Works, Dagenham. Saloon de Luxe (4 Doors), £145, at Works.

From places nearly as far apart as the Poles, every post brings messages of cordial appreciation of the Dagenham-produced 8 h.p. Ford, "The Leader of the Light Cars," with its powerful, smooth-running engine, its synchronised gear-change and silent second speed, really adequate brakes, and all-steel one-piece body-construction, affording lasting immunity from external damage.

Built to give trouble-free performance, on good roads and bad, in all climatic conditions — with exemplary economy of operation and exceptionally inexpensive maintenance.

FORD MOTOR COMPANY LIMITED
DAGENHAM, ESSEX. SHOWROOMS: 88 REGENT ST., LONDON, W.1

'Dagenham supplies the World' – 8HP Saloon, 1934.

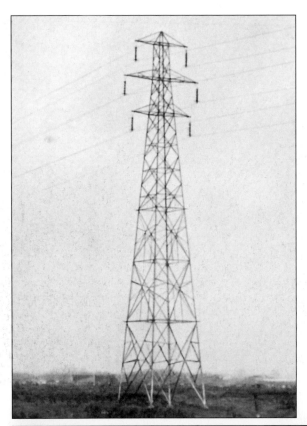

A typical two-circuit line tower on the British 'Grid' – many of the new features of growing industrialisation from 1931 were beginning to appear in the neighbourhood of Fords as other firms took up residence. Previously firms like Samuel Williams at the Dock had their own power station.

Dagenham Cables Sports FC. The new industrial firms by the Thames provided generous sports facilities for their staff.

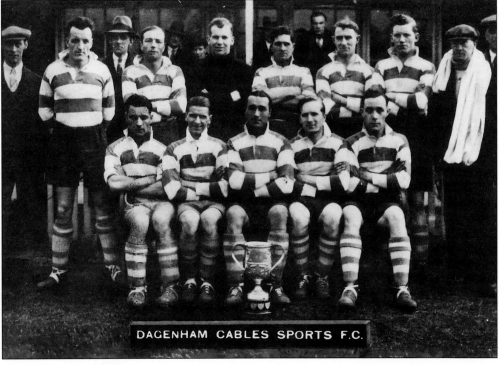

DAGENHAM CABLES SPORTS F.C.

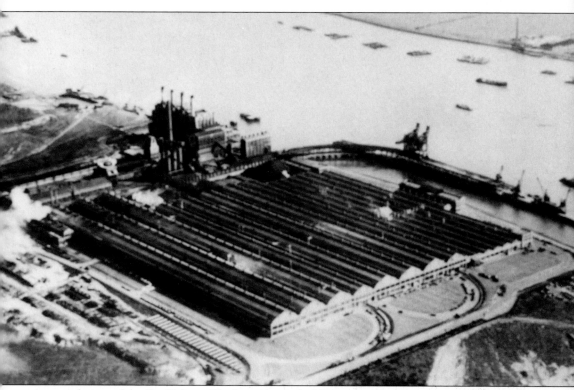

An aerial view of the Ford Motor Works in the early 1930s.

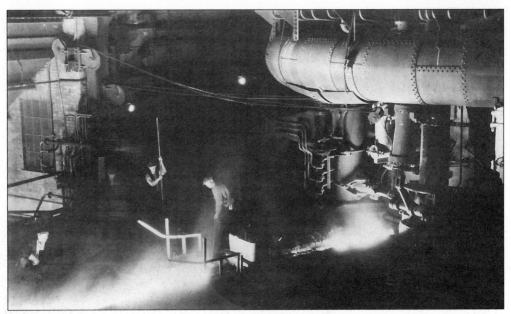

A view of pig-iron casting at Fords in the early 1930s.

Pouring the pig-iron at Fords.

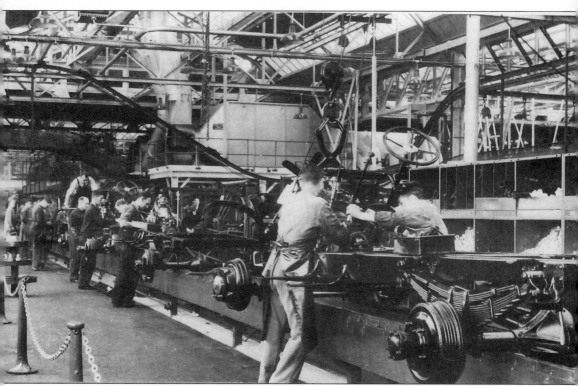

An interior view of the production line at Fords showing work on a chassis.

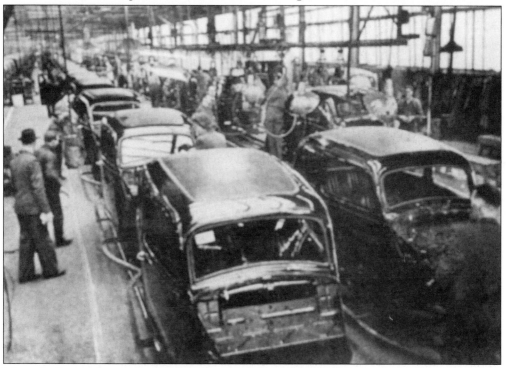

Motor bodies on the production line after the Second World War.

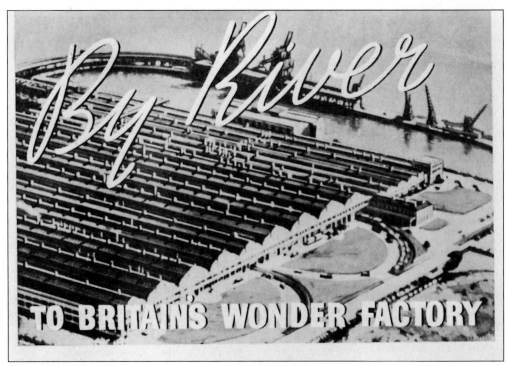

Advertisement for the river cruise which ends with a grand tour of Ford's 'Wonder Factory'.

The air-heating cylinders of the Blast Furnace, which smelts iron ore

River Cruises

Start from Westminster Pier, London, every Monday, Tuesday, Wednesday and Thursday, from May 2 to September 29, at 11.30 a.m., returning at approximately 6.15 p.m. 2½ hours are spent ashore at Dagenham. Fare 3s. 6d. return. Tickets should be taken in advance, and may be obtained from all Ford Dealers, from the usual booking agencies, or from the Ford Works, Dagenham.

Works Tours

The Ford Works can be reached readily by road or rail, and full details of the best methods of travelling will be sent on request. Factory tours start at 10 a.m. and 2 p.m. every Monday, Tuesday, Wednesday and Thursday. Special arrangements are made for visitors desiring to travel to the Works by air.

S.S. "Hurlingham"

The river steamer S.S. "Hurlingham" has been chartered for these trips. Accommodation is provided for 150 passengers.

On the River

A loud-speaker commentary adds to the interest of the cruise through the most historic and colourful reaches of London's river. Luncheon, tea and other refreshments may be obtained, and are served in the saloon, which commands an excellent view of the passing scene. The trip takes about 2½ hours in each direction.

Ford Factory

Over 12,000 men, aided by machinery that is among the most wonderful invented by man, make the Ford car at Dagenham. Tens of thousands of visitors come to the Ford Works every year to see their miracles of manufacturing ingenuity. Over 150,000 have travelled by river alone. You, too, should see Britain's industrial wonderland.

★ *Invitation* ★

The Ford Organisation invites you to visit Ford Works, Dagenham —either by the River Cruises described in this advertisement, or by Road, Rail or Air. Complete arrangements are made for the reception of visitors, and everything possible is done to ensure that you will spend an interesting, informative and pleasurable day.

For further information, and permits to visit the factory, write

**FORD MOTOR COMPANY LIMITED
DAGENHAM, ESSEX**

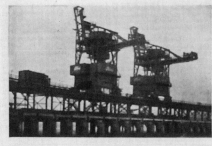

Electrical Unloaders, the largest in Europe, on the Jetty

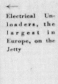

Tilting newly smelted iron into the Pig-Making Machine

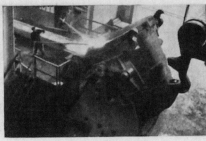

More details of the cruise of the steamship *Hurlingham*.

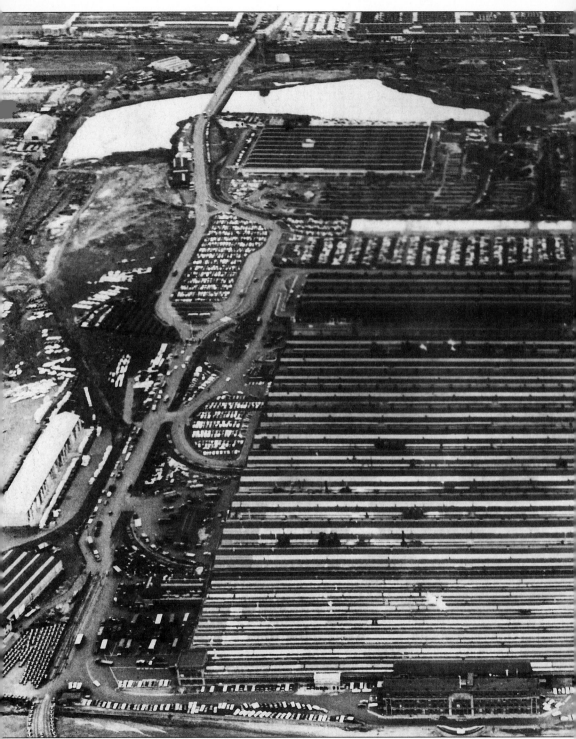

A post-war view of the Ford plant from the air. 'Ford has its own wharf for import of raw material and export of completed vehicles'. It also needed to maintain its own power house, blast furnace, coke ovens, foundries and gas holders.

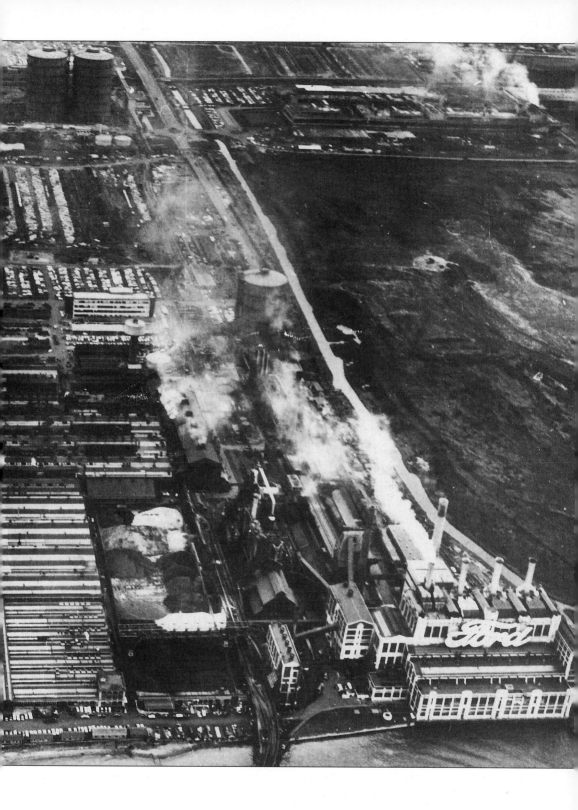

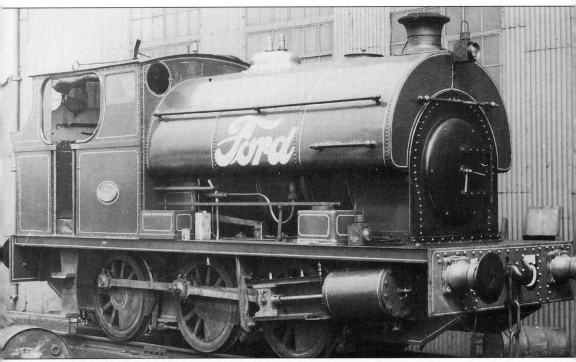

One of the very smart locomotives operating within the works. As well as steam there have been diesel engines on the Ford tracks.

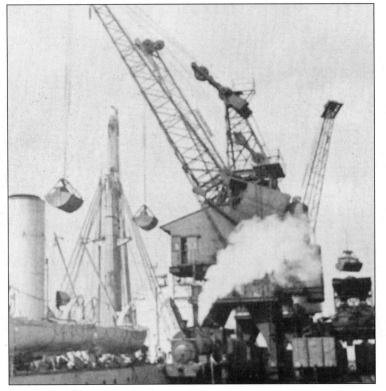

Unloading at Samuel Williams' No.7 Jetty in the late 1940s. With expansion after the Second World War, Williams offered sites for factories as tenants – offering their wonderful range of berthing, transport, handling equipment, maintenance and repair, and private rail and sidings facilities, probably unequalled in the London area.

Seven
A Community Develops
Dagenham from the 1920s

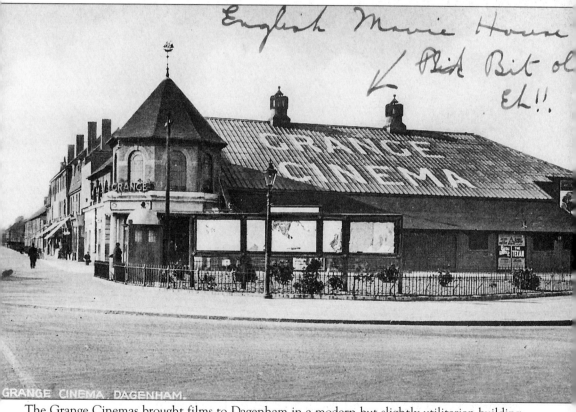

The Grange Cinemas brought films to Dagenham in a modern but slightly utilitarian building seen here in the 1920s. John Kay was the proprietor in 1928. Previously a trip to Barking, Romford or Ilford had been necessary to see the silver screen.

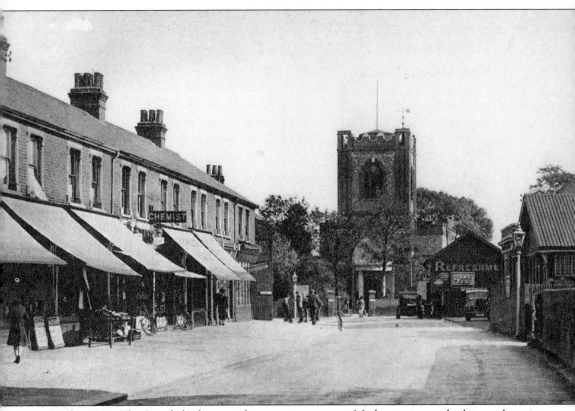

By the 1930s The Parade had matured into quite a successful alternative to the bigger shopping centres further away. It included a chemists, dairy, grocers and newsagents.

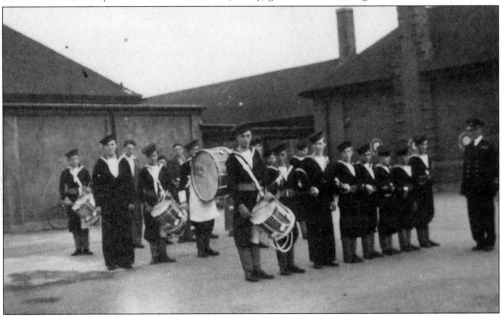

The Sea Cadets were one of a huge number of youth organisations that prospered in Dagenham. In this group is Seaman Bugler D. White.

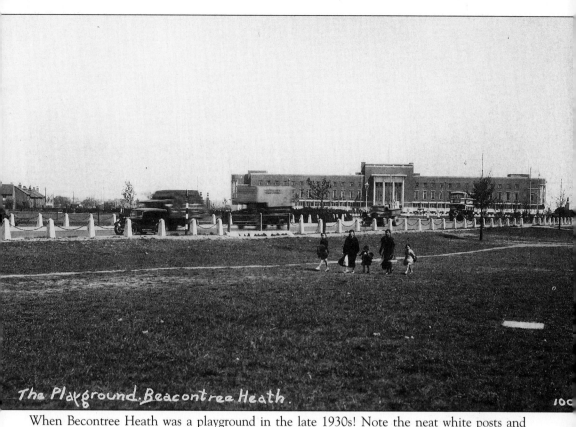

The Playground. Beacontree Heath.

10C

When Becontree Heath was a playground in the late 1930s! Note the neat white posts and chains separating it from the highway. The Civic Centre in the background was designed by E. Berry Webber and opened in 1936.

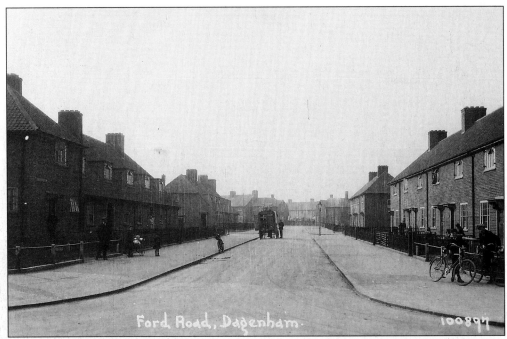

Two views of Ford Road showing housing with better facilities typical of the new Dagenham, although this road is very close to old Dagenham village, running between Heathway and Church Elm Lane. The convenient shop is that of Charles Gunary, greengrocers, 110 Church Elm Lane. In 1929 C. Gunary & Sons were also farmers at Manor Farm, not too far away.

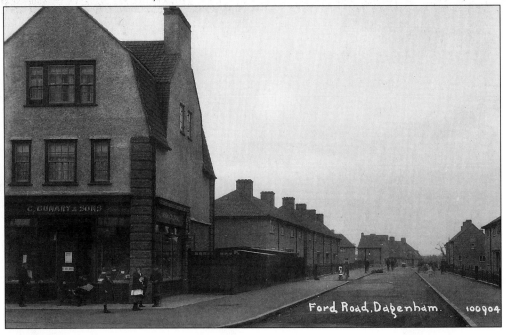

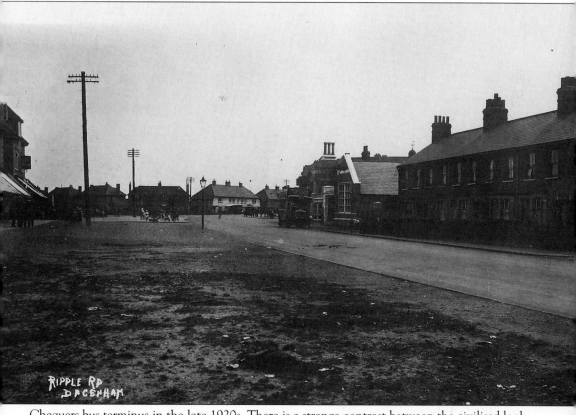

RIPPLE RD
DAGENHAM

Chequers bus terminus in the late 1920s. There is a strange contrast between the civilised look of the housing, bus, Chequers pub, shops and telegraph poles and the Wild West aspect of the very wide road verge in this photograph.

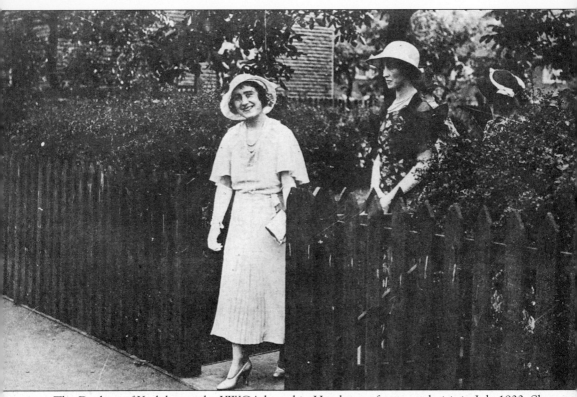

The Duchess of York leaves the YWCA hostel in Heathway after a royal visit in July 1933. She was later to become Queen Elizabeth in 1937.

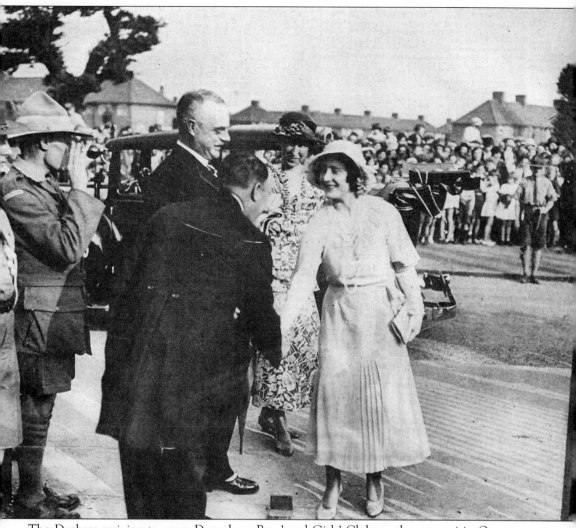

The Duchess arriving to open Dagenham Boys' and Girls' Club on the same visit. One can sense the pride of the locals in showing off an aspect of the new Dagenham.

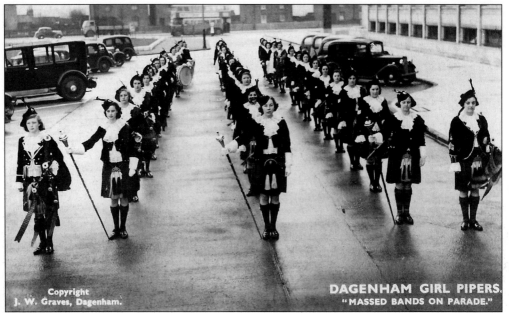

DAGENHAM GIRL PIPERS.
"MASSED BANDS ON PARADE."

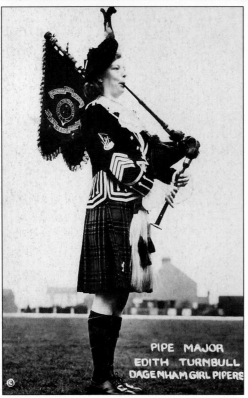

PIPE MAJOR
EDITH TURNBULL
DAGENHAM GIRL PIPERS

A remarkable outcome of the efforts of one local minister, the Revd J.W. Graves, to organise and give a sense of discipline and pride to local girls, was the creation of the Dagenham Girl Pipers.

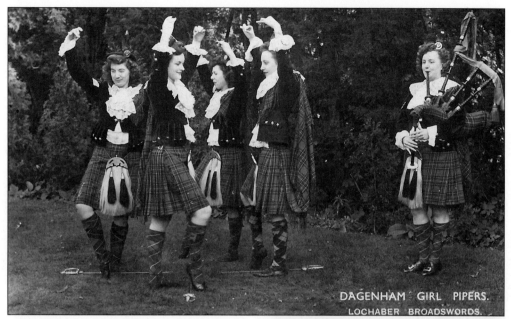

DAGENHAM GIRL PIPERS.
LOCHABER BROADSWORDS.

Graves had a natural affinity to the bagpipes and a real flair for showmanship unexpected in a pastor. The world's first band of girl pipers had not only captured the hearts of locals within a few years, but had carried the flag for Dagenham around the country and also won world-wide fame. Edith Turnbull, the first girl pipe-major, proved a born musician and with her, under the overall control of Graves, a stream of girls, fresh from school, flowed in for training. Eventually the girls took their nostalgic music to India, Africa, America and around Europe. They displayed their talents at the New York World's Fair in the peaceful 1930s and at remote troop camps in the Middle East in the warring 1940s.

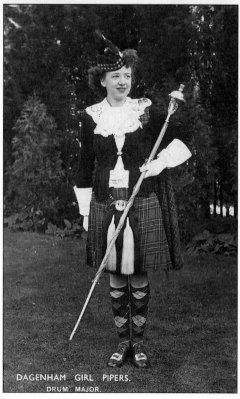

DAGENHAM GIRL PIPERS.
DRUM MAJOR.

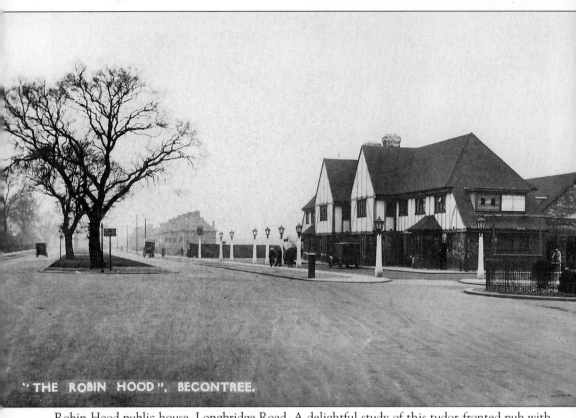

" THE ROBIN HOOD ", BECONTREE.

Robin Hood public house, Longbridge Road. A delightful study of this tudor-fronted pub with 1920s style lamps mounted on columns to light the night-time drinkers' way. The Becontree Estate, a significant part of the 'new' Dagenham, and the largest estate built in Europe was quite well supplied with public houses, new and old. Note the mature trees along the middle of the highway.

124

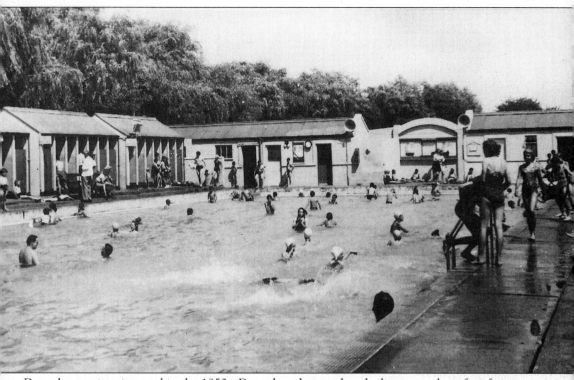

Dagenham swimming pool in the 1950s. Dagenham has produced a larger number of proficient sportsmen, some of whom became famous, such as Jim Peters, the Olympic marathon runner. New facilities and modern teaching in an up-to-date environment probably assisted this success.

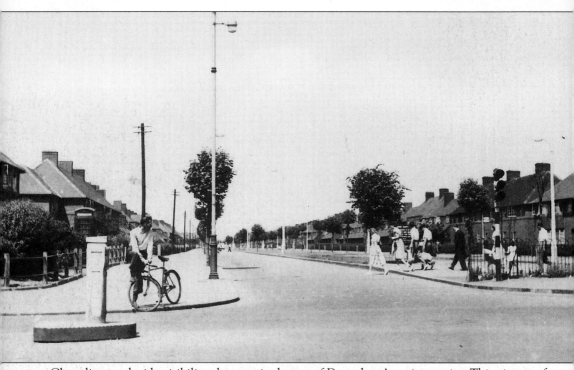

Clean lines and wide visibility characterised some of Dagenham's main arteries. This picture of Valence Avenue shows how it was built with a central reservation strip, originally used during the construction of the estate by the contractor's rail line.

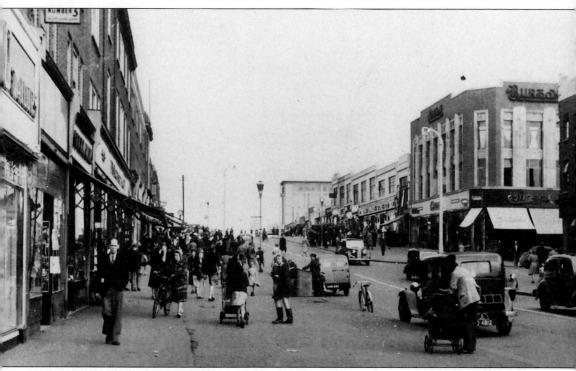

The planned shopping centres were often placed near a railway station for maximum convenience of access, as at Heathway. The great days of pedestrian shopping which lasted through the 1930s, 1940s and 1950s, as in this picture, and for another decade after have gone, and many of the prosperous local and national businesses have left the parades. Shopping is now mainly carried out at the weekend, out of town, and by car.

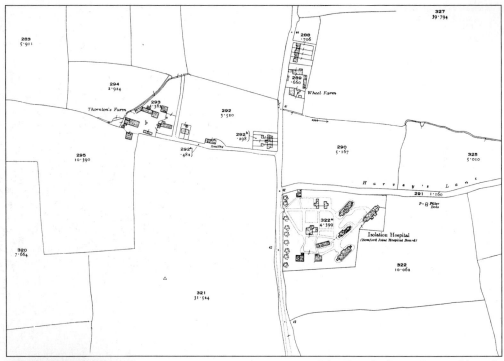

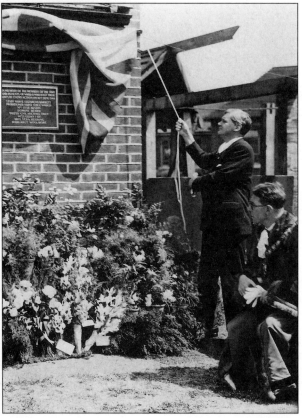

The Romford joint hospital board built an isolation hospital at Rush Green, over the Dagenham border in 1901. As can be seen this was in the midst of farms and fields keeping contagious patients safely away from the rest of the population. Up to 1929, before the age of antibiotics, there were beds for seventy-eight patients. It was extended in 1907 at a cost of £14,500 and a nurses home was built on the site in 1925. Above is a plan of the area in 1914. Housing and Romford crept nearer so that in the Second World War it was in the danger zone. Left, Aneurin Bevin unveils a plaque on a rebuilt wing in memory of staff and patients killed by a wartime bomb.